WATERLOO HIGH SCHOOL
146
ATW.
W9-BHG-420

Purchased Under Federal Program
TITLE II
Waterloo Local Schools

Pastel Painting Techniques

(*Overleaf*)
JEAN BAPTISTE SIMEON
CHARDIN 1699—1779
1 *Self-portrait with Pince-nez*
The Louvre, Paris
This fine pastel achieves a monumental
simplicity without any traces of the sort of
technical display of which La Tour is
sometimes guilty. Notice the diagonal
strokes of the pastel moving across the
form of the head.

As in the case with the self-portrait
with the eyeshade (38), the spectacles
here seem to help the form

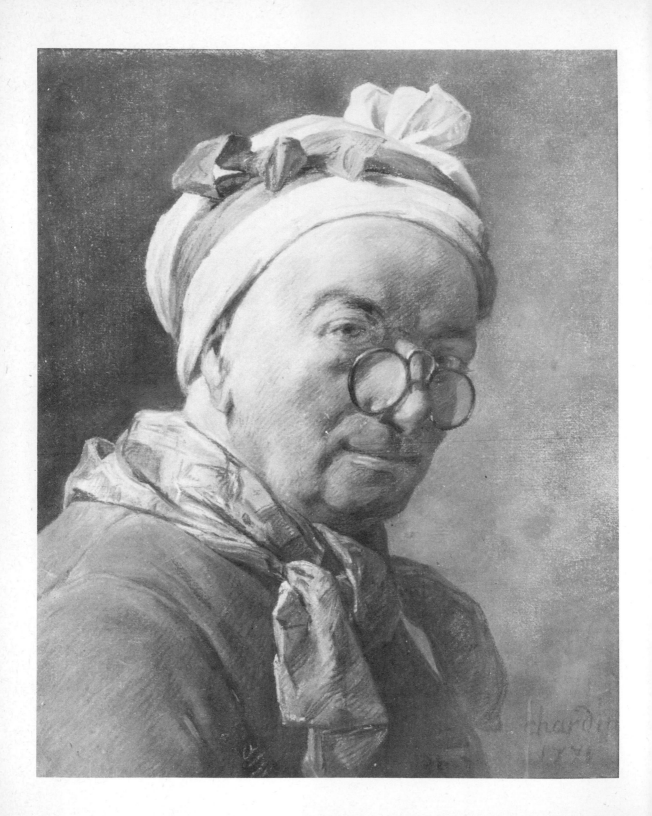

WATERLOO HIGH SCHOOL LIBRARY
1464 INDUSTRY RD.
ATWATER, OHIO 44201

Pastel Painting Techniques

GUY RODDON

Larousse & Co., Inc. New York

741.2
Rod

Dedicated to my daughters
Diana, Victoria and Louise

© Guy Roddon 1979

First published 1979
in the United States by Larousse & Co Inc
572 Fifth Avenue. New York. NY 1006

ISBN 0-88332-108-4
LCCN 78-71759

Printed in Great Britain

Contents

Acknowledgment 6
Introduction 7

The characteristics of pastels 9
 Composition
 Advantages and disadvantages
Drawing 14
The palette and choice of colours 15
 Tint charts
 A working palette
 Suggested palette for portraiture
Supports 22
 Ingres paper
 Preparing the paper
 Texture of support
 Other supports
Methods 27
 Drawing and painting with pure pastel
 The lay-in of the design
 (a) charcoal drawings heightened with pastel
 (b) charcoal combined with pastel
 Developing the pastel after the lay-in
 (a) modelling by tone
 (b) modelling by colour and line
Mixed media 46
Fixatives 49
Mounting and framing 51
Storing pastels 56
History of the medium 57
Stages in the making of pastels 106

Glossary 110
Bibliography 113
Suppliers 113
Index 115

Acknowledgment

My grateful thanks are due to Miss Lilian Browse of the Browse and Darby Gallery, Cork Street, London W1 for the Sickert pastel, to Mr Peyton Skipwith of The Fine Art Society, London for the illustrations and interesting information on the work of Edward Stott and George Clausen. I am also indebted to Baron André de Moffarts for the portrait by Franz-Josef Pfeiffer; to Robert Buhler, RA for his encouragement and the portrait of Lady Prudence Branch; to Jeremy Grayson for technical photographs; to Mrs Glenda Malley who typed the script; to various museums and collections in England, France and the USA who provided illustrations and Thelma M Nye of Batsford who helped track them down.

London 1978 GR

Introduction

The purpose of this book is to introduce the student to the history and technique of pastels.

The history of the medium in its purest form is not a long one: pastels first achieved recognition and popularity in the eighteenth century with such masters as Quentin de la Tour, Perronneau and Chardin and in the nineteenth century with the works of Manet, Degas, and Mary Cassatt, when the medium seemed so suited to the aims of Impressionism.

It is a pity that pastels have been associated in the popular mind with sugary and over-sentimental portraits of children, when its range in subject matter and technique is much wider.

The best way to understand the medium and to master its technical possibilities is to look at the work of the great pastellists of the past. This book will not be exclusive to portraiture, although many of the best examples are in this genre, but will attempt to illustrate the possibilities of the medium in its widest sense. Thus the illustrations have been chosen as much for the technical information they give as for their historical interest. For it has been the practice of painters down the ages to base their work on close study and analysis of the acknowledged masters who preceded them.

The illustrations will be distributed throughout the text where they are relevant to points of technique under discussion.

There is no substitute for seeing work at first hand. It seems, however, that as most of the great masters are French, many of the best examples are in France. However, in England, fine examples helpful to the student, can be studied in the National Gallery and The Tate Gallery, London, the Fitzwilliam Museum, Cambridge, and The Ashmolean, Oxford. In the United States superb examples can be seen in collections such as those in The Metropolitan Museum, New York, The Art Institute of Chicago and The Boston Museum of Fine Arts. It is hoped that this book will encourage and interest those who are coming to the medium for the first time and also serve as an introduction to the great masters who have used the medium so successfully.

The charm of pastels lies particularly in their freshness and delicacy of hue and in many cases their apparent spontaneity when the picture, catching some momentary aspect of nature or the sitter, appears to be almost breathed onto the paper. The range of subtle pastel shades, in the rendering of flesh, for example, is characteristic of the medium and, in my view, is more effective when thinly applied, as in the classic tradition of the eighteenth century, rather than loaded. Of course there are exceptions to this procedure and Degas, with his system of cross hatching over successive layers, is a case in point.

Pastel is both a drawing and a painting medium and has some of the qualities of each. However, a pastel, whether a portrait or a landscape, should not try to imitate an oil painting or for that matter be thought of as a substitute for oil paint. The medium has its own qualities to exploit and enjoy. Care must be taken not to overstrain the medium otherwise the picture will look overworked, the particles of colour tend to clog and the freshness and spontaneity of the *premier coup* will be lost.

The success of a pastel picture, more than in any other medium perhaps, depends on good sound drawing; this cannot be overstressed and is absolutely essential for portraiture and figure work. One of the reasons being that, whereas in oil painting, if a mistake is made, it can be eliminated with a turps rag, and the artist can begin again; alterations in pastel require a more elaborate surgery than those of the first lay-in of an oil painting. A mistake in pastel may be brushed off with a hog hair brush or erased with a putty rubber, but the more one does this the more the surface of the paper is disturbed and the less chance there will be of that lightness of touch that gives the medium so much charm.

What then are pastels? Pastels are powder pigments mixed with just enough gum or resin to bind them into solid sticks. The binding medium is usually gum tragacanth. The pigment is generally mixed with a filler such as pipe-clay which, being white, is responsible for the so called pastel shades associated with the medium. The filler also improves the covering power.

Pastels are soft, medium or hard according to the amount of agglutinant in the paste. If the proportion of gum is increased there is a loss of brilliance in the colour and thus the most brilliant sticks are those which are the most

The characteristics of pastels

Composition of pastels

9

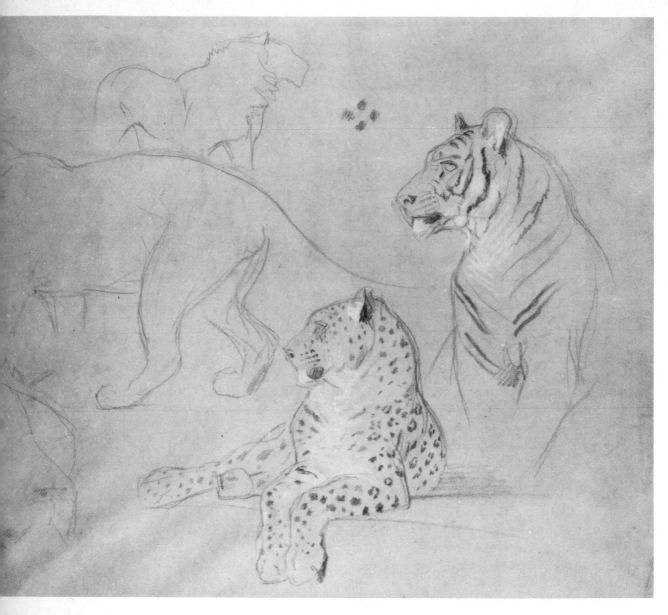

SIR EDWIN LANDSEER 1802—73
2 *Studies of Tigers and a Leopard*
The British Museum, London
These chalk drawings on toned paper
show how very good Landseer could be
when he drew animals directly from
nature before incorporating them into his
over-sentimentalized paintings

10

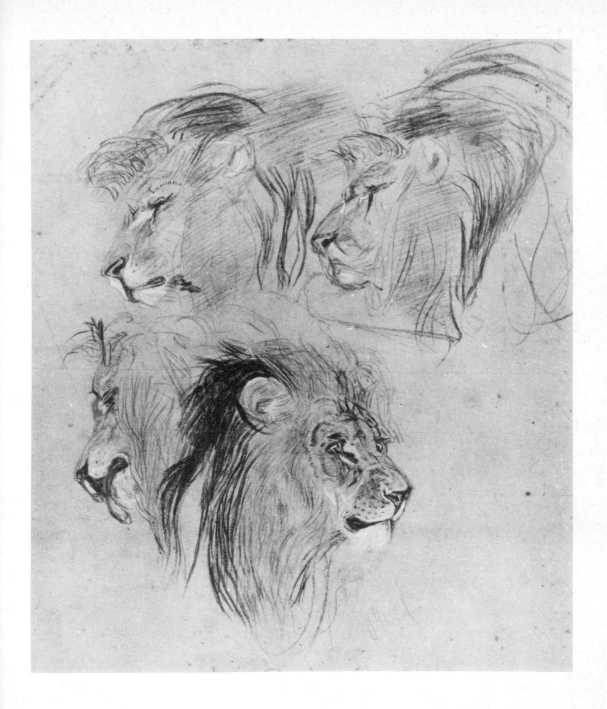

3 *Studies of a Lion's Head*
The Courtauld Institute of Art, London
Black, red and white chalk on buff paper

11

fragile. This fragility is clearly a disadvantage as the sticks are liable to break and crumble. But one cannot have it both ways. Pastels in the eighteenth century were occasionally described as crayon drawings; a confusion in terms with the harder chalk or crayon composed of oil or wax. Chalk drawings on toned paper tinted with white such as one finds in the work of Fragonard or Watteau and in the chalk drawings of animals by Landseer, are not strictly speaking pastels but deserve to be studied as a preliminary approach to the medium, and as a basis for a more developed pastel, rather as early topographical watercolours had a monochrome base over which colour was added.

Advantages and disadvantages

Pastel allows the artist to paint and draw straight away in full colour; indeed the colours can be so brilliant as to be almost intimidating when one first uses them. This may be the experience of the oil painter, used to painting in tonal modulations. The range from light to dark is less than that of oils owing to the mixture of the white filler in the colours and it takes some time to learn to handle the medium in a simple and telling way. Manet, for example, with his portrait of George Moore (22) took to pastels naturally since it was more an extension of his oil painting technique where the flesh colour is applied flat with few modulations and the form is expressed by the drawing of the contour.

A further advantage is that with pastel there is no drying time, nor sinking, nor alteration of tone after drying as is so often the case with oils and watercolours. The colours do not fade nor do they darken and they remain as fresh as when originally painted. They also have the advantage of permanency, provided they are carefully framed and not man-handled to dislodge the fragile surface.

The freshness of the medium seems to give some pastels, particularly the eighteenth century portraits of La Tour, a curious sense of leaping backwards and forwards in time, where his sitters, drawn with such psychological insight, come alive to us as contemporaries without the intervening centuries sealing them in their period. Of course this feeling of contemporaneity may be something to do with the particular intimacy that much graphic work possesses but it can be ascribed as well to the directness and spontaneity of the medium itself, which is admirably suited to the recording of transitory and fleeting observations of daily

12

experience. Perhaps because of this it has been argued that pastel is not capable of making as profound a statement as oil painting and this may account for the medium being relegated to an inferior position and not worthy of serious consideration. The work of Degas, alone, has surely given the lie to this opinion and the effects of spontaneity which we associate with his work was often the result of a process of elimination through several drawings, sometimes using tracing paper over the original key drawing in order to arrive at a distillation of the motif.

Drawing

It is not the purpose of this book to treat the subject of drawing in any great detail. Good draughtsmanship, as has been said, is indispensable when working in this medium and weak drawing will easily be detected. It is assumed that the artist has obtained a degree of proficiency in drawing.

When it comes to pastels, as with other media, good drawing is much a question of selection, of knowing what to put in and what to leave out since much of the charm of pastels is due to its quality of suggestion.

The various effects produced by different ways of holding the panel stick will be discussed later. (See Methods, page 27.)

But a statement by Degas on an approach to drawing should be included here.

'It is all very well,' Degas says, 'to copy what you see, but it is much better to draw only what you still see in your memory. This is a transformation in which imagination collaborates with memory. Then you only reproduce what has struck you. That it so say, the essentials, and so your memory and your fantasy are freed from the tyranny which nature holds over them.'

Before discussing the various supports and surfaces on which to work — the range of coloured papers naturally influence the result — the choice of colours should be considered.

We have to set up a good working palette for portraiture and landscape and to choose it from an enormous range of colours. The range and layout of colours is very different from the traditional palette of the oil painter, who may use no more than eight or ten colours and from these produce from mixtures an infinite number of colours and tones. Indeed once he gets to know the mixtures that he can make from a few colours, he may be surprised how much he can achieve with limited means.

But for the pastellist who has been used to working in oils the change-over to this medium takes some getting used to. From a range of three hundred to six hundred different tints a manageable quantity has to be selected to suit individual needs and the choice, as with that of the paper, is a personal one as one familiarises onself with the various possibilities.

It is, at least, enjoyable finding out just what can be done. But the first daunting experience occurs when confronted with such a vast and varying range of colours and wondering how to set about making a choice.

In my experience the most effective way to learn the colours is either to make a tint chart or to use a printed one such as Rowney & Co provide. (See page 18.) On a sheet of white paper the names of the colours are printed in columns. Space is provided against the name of each colour for the artist to make a pastel tint record, using his own pastel sticks.

It is important to understand something of the numbering references of the different makers. The numbers refer to the various strengths of each colour. For example a light Burnt Umber has the number 1 after it and the darkest version the number 8. An ultra-marine pastel made by Rowney in a range of nine tints from 0 to 8 has number 8 as the deepest tint. This system of numbering the tonal range of a colour is applied to all the colours on the list, and when making a selection from the colour merchants this should be borne in mind.

The Tint Chart is therefore a very useful guide; but beware, the system is not standardized and varies with different makers. The Dutch firm of Talens, who make

The palette and choice of colours

Tint charts

15

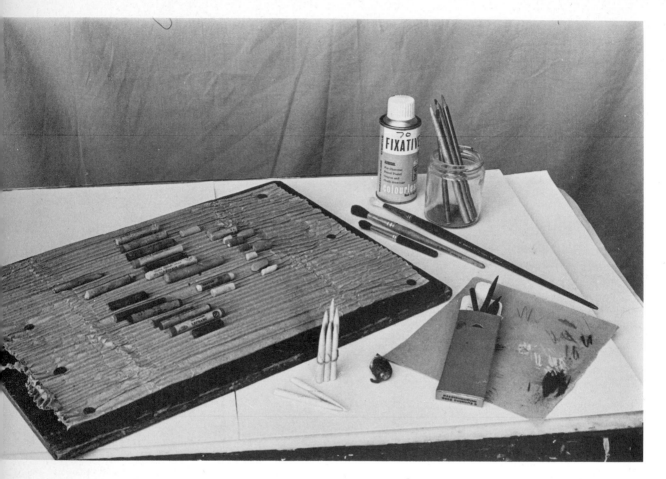

4 Display of essential materials showing
pastels laid out on corrugated paper;
stubbing pencils for blending; charcoal
sticks and glass paper for sharpening to a
point; soft and hard brushes for removing
pastel; putty rubber, pastel pencils and
fixative in an atomizer

5 The picture on the easel at an angle
with an improvized tray to catch the
broken pieces of pastel and the pastel dust

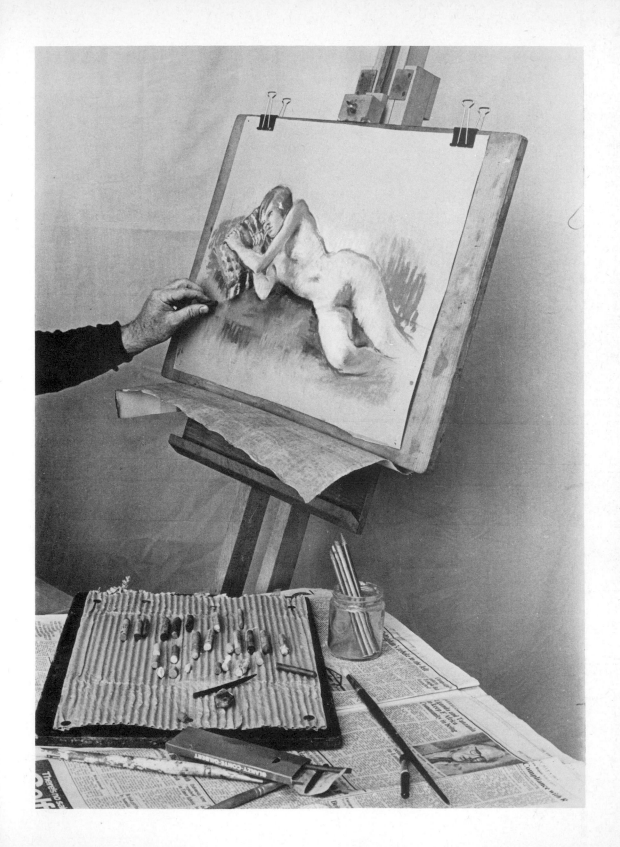

ROWNEY Artists' Soft Pastels Tint Chart

Yellows & Oranges

Cadmium Yellow	1
	4
	6
Cadmium Orange	1
	4
	6
Cadmium Red Orange	1
	3
Lemon Yellow	0
	2
	4
	6
Naples Yellow	0
	2
	4
	6
Raw Sienna	1
	4
	6
Yellow Ochre	0
	2
	4
	6

Reds

Burnt Sienna	0
	2
	4
	6
	8

Cadmium Red	1
	2
	4
	6
Cadmium Tangerine	4
	6
Crimson Lake	0
	2
	4
	6
Indian Red	0
	2
	4
	6
Poppy Red	1
	3
	6
	8
Red Grey	0
	2
	4
	6
Rose Madder	0
	2
	4
	6
Vermilion	0
	2
	4
	6

Violets

Mauve	1
	2
	3
	5
	6

Pansy Violet	1
	3
	5
	7
	8
Purple	0
	2
	4
	6
	8
Purple Grey	0
	2
	4
	6
Reddish Purple	1
	3
	6

Blues

Blue Grey	0
	2
	4
	6
Cobalt	0
	2
	4
	6
Coeruleum	0
	2
	4
	6
	8

ch Ultramarine	0	Lizard Green	1	Madder Brown	0		
	1		3		2		
	3		5		4		
	4		7		6		
	6		8		8		
	8	Olive Green	0	Purple Brown	1		
o	1		2		4		
	3		4		6		
	4		7	Raw Umber	1		
	6		8		3		
sian Blue	1	Sap Green	1		4		
	3		3		6		
	5		5	Sepia	1		
	8		8		3		
		Terra Verte	1		5		
			5		8		
			8	Vandyke Brown	1		
		Viridian	1		2		
ns			4		4		
			6		6		
Green	1	Yellow Green	1		8		
	5		3	Warm Grey	1		
	8		5		3		
		Browns & Neutral			4		
ant Green	1	**Greys**			5		
	3	Autumn Brown	1	**Blacks & Whites**			
	5		3	Intense Black			
	6		5	Ivory Black			
			8	Lamp Black			
s Green	1	Burnt Umber	1	Silver White (blue shade)			
	4		2	White (cream shade)			
	6		4				
n Grey	1		6				
	4		8				
	6	Cool Grey	1				
			2				
			4				
ker's Green	1		5	George Rowney & Company Limited			
	3		6	P.O. Box 10, Bracknell, Berkshire			
	5						
	8						

Rembrandt pastels, employ a different scheme giving each colour an individual shade reference number. For example Ultramarine deep is number 60. A series of decimal points after this figure denote the percentage of white added to the colour; 60.9 being the palest blue, having 80 per cent white added and 60.2 has 60 per cent black added to make a dark blue which is nearly black. The pure tint of the colour would be 60.5.

These various systems of numbering allow the artist to choose a colour which is at least tonally correct. But in general it would seem simpler to choose perhaps a light, dark and middle tone of a particular colour and so reduce the number of sticks to be used.

The chart is printed on white paper, which is seldom the colour that one works on but it should not be difficult to transpose mentally as a painter does when working from a brown palette to a white canvas.

A working palette

Rowney have tried to simplify the problem by boxing up sets of twelve pastels for landscape, and twelve for portraiture and a further set of thirty-six pastels for general use.

My own advice would be to restrict the palette to a few colours, perhaps no more than a dozen, adding to them by degrees, as you get to know what you can do with them. Both Rowney's and Talens' pastels, are readily obtainable in the UK and in the United States the firms of Grumbacher and F Weber also make fine pastels.

The importance of having a good supply of middle range greys both warm and cool, should be mentioned here. In portraiture they are indispensable. On a warm grey or heather mixture Ingres paper, Rowney's Green Grey number 1 and 4 and Warms Grey Tint 3 and 4, Series A are useful half tone colours: but so important is the colour and tone of the paper in the overall scheme that these colours, as with most others, will appear very different according to the paper on which they are used. It is helpful to spend some time applying a range of flesh colours to a swatch of various coloured papers. In time and with your personal inclinations, you will know which colours are the most telling and on which ground. This marriage of paper and pastel applies not only to colour but also to texture. (See Supports, page 22.)

Burnt Sienna	0		Rowney
Red Lead	4 ton	LIGHT	Le Franc 1334
Madder Brown	2	FLESH	Rowney
Yellow Ochre	0		,,
Madder Brown	0	REDS	,,
		for	
Rose Madder	0+4	MOUTH	,,
Green Grey	1	HALF	,,
Grey Tint	4	TONES	
VAN DYKE BROWN	4	MIDDLE	,,
RAW UMBER	4	AND	
MADDER BROWN	8	DEEP	,,
GREEN GREY	6	TONES	
COBALT Blue	4		
CERULEUM	6	Blues	

Naturally these colours may be expanded and it is suggested that a middle grey Ingres type paper is used to experiment with the colours of this palette. Rowney also produce a portrait box of 36 tints, a wider range than that given here and without wasteful duplication.

A pastel by Le Franc is included; it may be difficult to obtain but I would emphasize that your pastel box should, in time, include pastels made by a variety of manufacturers if you are on the look out for new and varying tints. Some artists indeed prefer to make their own, a complicated process (see page 106), as they find that the subtle tones for which they are searching, particularly with the greys, are not always readily obtainable from the colour merchants.

The labels frequently get torn or covered with dust and sometimes it is difficult to read the name or number of the colour being used. They should therefore be laid out methodically in the box according to colour and tone and always replaced in the same position. The colours in the box should be noted before use so that you know precisely what you need when re-ordering. When selecting from the box for immediate use, the sticks should be laid out on a sheet of corrugated paper pinned to a board which will prevent them rolling about and breaking. (See 4 and 5.)

Supports

The artist should acquaint himself with the differing paper surfaces and supports in the same systematic way that he gets to know the colour chart and palette. As has been said, the picture is a marriage of pastel and paper. The artist must find a paper or other support, with a texture sympathetic to the touch as well as a colour and tone which does some of the work by producing a useful middle tone in portraiture or perhaps a shadow in landscape.

It takes time to find what one wants, and in the same way that oil painters get used to a particular tooth to their canvas and know what they can do with it, pastellists should find the right textured surface for their needs. This choice is naturally personal and will come with experience; however, initially, a swatch of differing papers should provide the basis for experiment.

The aim should be to find a paper and texture suitable for the subject, since the colour will often be left showing to work in with the overall scheme. So obviously the colour, if not the texture, will change with the subject.

Paper will often vary in weight as will be seen in the list below.

Ingres papers

Ingres type papers have a very sympathetic grain which is agreeable to the touch and responsive to a variety of expressive strokes, and it is the paper that many artists find the most pleasant to work on. Watercolour and gouache may be used in washes applied normally by brush or colour mixed in a jam jar and applied with a mouth spray. All these methods are intended to provide interesting grounds to work on and to influence the design and it is the greatest bore to have to cover the whole page, whether it is a hand prepared paper or a manufactured one, in order to eliminate a background colour which is unsuitable.

Fabriano Ingres paper is produced in weights of 90 gm and 160 gm and Ingres Tumba (Swedish) paper at a weight of 104 gm.

The range of colours of these papers, as with Ingres Canson, is very wide extending from fifteen to twenty shades. The middle tone Tumba papers, for example blue grey: purple grey: mid green: pale jade, allow for subtle colour harmonies, while the darker rusts and browns compel the artist to force out the contrasts and lay in with firm charcoal drawing. Some artists have worked on black or dark greys and blues, as was the case with Eric Kennington with his Great War pastels. Here the contrasts are forced

22

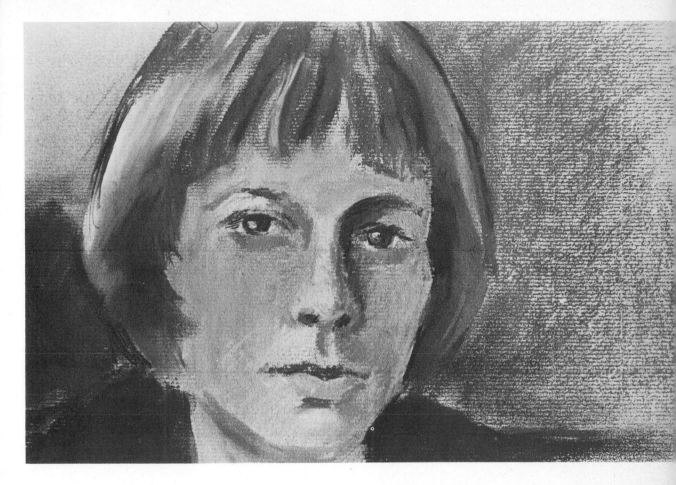

GUY RODDON 1919
6 *Detail from a portrait of Harriett Gilbert*
The detail illustrates the grain of the Ingres paper which is allowed to show through to enliven the background. The grain is lost by rather heavier application of the pastel on the face and re-occurs in parts of the hair which is also rubbed with the hand and crispened with strokes from the charcoal stick. An attempt is made to give textural variety

23

WATERLOO HIGH SCHOOL LIBRARY
1464 INDUSTRY RD.
ATWATER, OHIO 44201

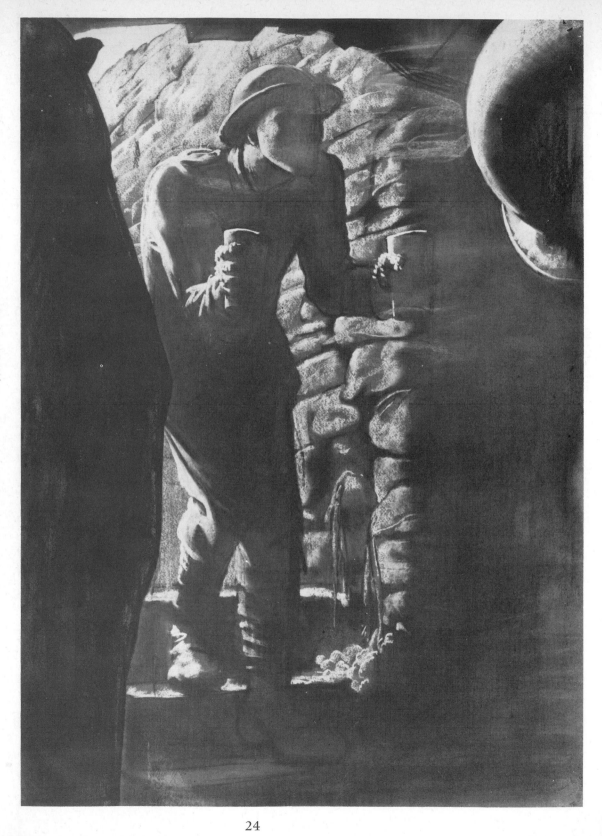

dramatically (7). Whistler frequently used a dark brown paper for his studies of Venice and he was fastidious in his choice of papers for his subjects. Some artists make selections for autumnal landscape from warm brown papers and cool blues and greys for winter subjects, using the paper to express the shadows.

But some artists prefer to prepare their own paper with a water colour or gouache wash and, since tinted papers tend to fade, the advantages of doing this are considerable, and it was a practice employed by Quentin de la Tour who give a tinted blue ground to his paper as well as a textured surface.

The pastellist Keith Henderson has suggested numerous ways of colouring the paper which should be mentioned here.

Fine glass paper can be bought from a hardware shop. If the individual pieces are too small, try ordering them from a wholesaler, who probably manufactures the sheets in rolls. The colour is a very good buff middle tone and grips the particles of colour very well and produces just enough resistance to the drawn line to give the strokes boldness and authority. On the other hand some artists find the surface too gritty and perhaps hazardous to the knuckles. The surface is at the opposite end of the scale from the delicacy of fine muslin.

Henderson suggests trying
(i) powdered Red Ochre from broken bits in the pastel box: crush these to a powder with the flat of the hand; spread evenly and put the paper under the tap and leave to dry.
(ii) Cadmium Red and Cobalt Green diluted with water and yolk of egg.
(iii) Burnt Sienna sprayed with Ceruleum Blue: Naples Yellow sprayed with Cassel Earth.

Henderson also suggests tea leaves. In fact, the student should derive a lot of fun by experimenting with various grounds for toning his paper. In the writer's view, the background colour should have variety within a tone so that the colour of the surface is not too mechanical and boringly even. One is reminded of the grounds of the great oil painters, in particular Rubens with the streaky grey and mother-of-pearl broken ground for his oil sketches.

The use of egg seems to be a survival from Tempera and Henderson quotes a letter of La Tour, 5 March, 1770:
'I have been treating blue paper with a light wash of

Preparing the paper

Eric Kennington
7 *The Cup Bearer*
Imperial War Museum, London
A fine example of Kennington's work as a war artist in the First World War. The dramatic lighting is achieved by contrasted light and dark without intervening half tones and using the dark tone of the paper. A dark paper was the right paper for a subject of this nature

25

yellow ochre diluted with water and yolk of egg. This minimizes the heavy effect of the quantity of colour necessary for covering the blue.'

In this case La Tour must have covered the entire paper with blue and applied the ochre wash to give the ground variety. La Tour, who is so often quoted because he was a superb technician as well as a very great artist, used to apply gum water to his paper which then received a sprinkling of vitreous blue pigmented smalt, which provided the tooth and tint to the ground.

One may also give a tooth to supports by sprinkling finely pulverised pumicestone powder to a covering of wet starch paste. The surplus powder should be lightly tapped off by gently knocking the corner of the board to which the paper is fixed.

Texture of support The texture of the support is as important as the colour, if not more so. The texture of the surface will hold the particles of the powder colour of the pastel stick. If the surface is too rough it will shave off the colour too liberally and if it is too smooth the colour will not adhere. Further, as has been said, the texture will influence the strokes and touches drawn upon it. (See Methods, page 27.)

Other supports Muslin pasted to a stretched canvas or to board is a suitable support for pastel, and in the past vellum has provided a surface for delicate work. Pastels on canvas are pleasant to work with but it is recommended that the size used in preparing the canvas should not be an animal glue, which can be a destructive in pastel since it is responsible for mildew germs. Caseine, glycerine or gelatine are better. The back of the canvas should be protected from blows or vibrations, which may dislodge the colour, by fixing card to the stretcher.

DELACROIX experimented with pastel on fine canvas treated with size water and allowed to dry. When finished, the picture was sprayed with hot steam to soften the size. The hot steam may also be applied from underneath the canvas, which is protected from the spray by being held flat and horizontally. The result is painting with distemper and there exist many beautiful pastel studies for example, in the Louvre his *Death of Sardanapalus* where he tries to arrive at the subtle tones of pastel and incorporate them into the oil painting.

26

Drawing and painting with pure pastel

The pastel stick is capable of a range of expressive strokes and experience will familiarise the beginner with the different angles and ways of holding the stick and the various marks it produces. Lines of different thickness from the sharp edge of the pastel to the mark produced by holding the pastel on its side will give some idea of the variety of effect, particularly when applied to different textured papers. Exercises should be devised to illustrate this (8).

The strokes should be confident and free since a timid gesture will lack authority and result in a weak drawing. Varying the pressure will reveal a further potentiality of the pastel, for a deeper tone is obtained from increased pressure. Here the pastel has been pressed into the grain and filled it up, whereas lighter strokes will pass over the surface of the grain. Overloading is caused when the pastel has filled up the grains of the paper, and it is almost impossible to continue with further layers of colour without clogging and the strokes slipping, so it is advisable to make preliminary strokes tentative but firm and build up the picture gradually, otherwise you will have to go through the business of brushing off the surplus powder with a hog hair brush and risk impairing the surface of the paper.

Colours can be blended with a stump or torchon or with the fingers but too much indulgence in this process will result in a smeared and slick surface which is disagreeable and a system of cross hatching is often a more effective way of blending the colours.

Pastel pencils, such as Othello pencils made by the German firm of Schwan, are useful for outlining the contour of the head or objects in a landscape and are helpful where precision is required. They can be given a point more easily than the soft pastel stick and are useful in the delineation of an eyelid or the highlight of a pupil.

If the pastel paper is clipped to a drawing board care should be taken to see that the surface of the board is smooth otherwise the grain of the wood will show through when the pastel is applied.

Pastels, because of their immediacy of impact, may some-times give the impression of having been dashed off in a short time in a racey sort of way. In fact sitters no doubt commission pastel portraits to spare themselves long

Methods

The lay-in of the design

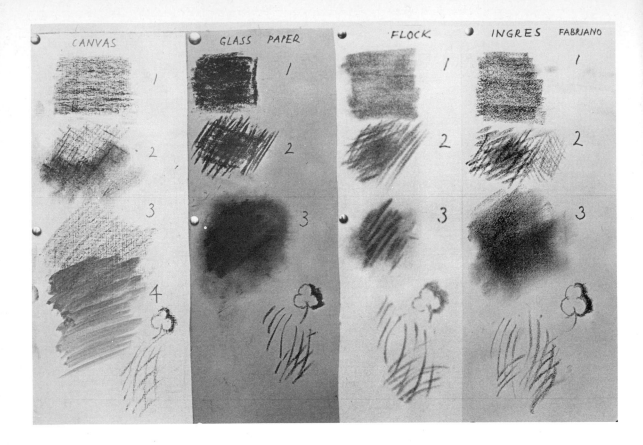

8 *Pastel marks on different surfaces*
The illustration shows the change in the appearance of the pastel mark when it is applied to different surfaces. Here are just four. I could have included muslin but the Manet pastel *At The Cafe* (56) is drawn on this ground and will illustrate the character of that. In each case I have attempted to apply the same pressure of the pastel stick to the surface

Canvas
The pastel used on its side shows very well the tooth of the canvas but does not fill up the grain too well and thus appears lighter in tone than expected. Section 3 and 4 on the canvas support illustrate the pastel applied in diagonal strokes and then spread in gradations with a wash of pure turpentine. Although the canvas is a fine grained surface, in this instance, I would be inclined to reserve the canvas support for oil pastels used by themselves or with turpentine as a medium.

Glass paper
Some painters find this support difficult to manage because it shaves off the particles of pastel severely. However, it does produce a rich tone, as will be seen, and the rubbing and fusing in Section 3 is particularly effective

Flock
It is difficult to spread the colour on this support but it is an agreeable surface to work on for soft effects

Ingres Fabriano
The Ingres papers are for many the most sympathetic surface to work on, particularly as the grain of the paper gives a quality absolutely suited to the pastel touch. It is recommended that students buy swatches of the various types of Ingres paper for their texture as well as their colour. The illustration of the head (6) shows very well the quality of the grain of the paper in the background when lightly drawn over, the build up of the pastel on the face and the incised marks of the charcoal on the hair.

28

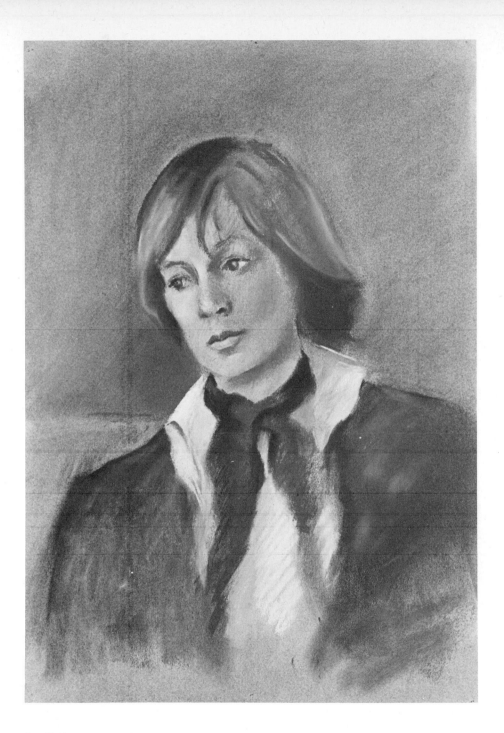

Guy Roddon
9 *Harriet Gilbert*

Here I have attempted to make use of the maximum pattern value and silhouette shape of the subject. Drawn on middle grey paper, I covered the background behind the head with a tone somewhat darker in order to force out the white of the shirt. The darker tone of the scarf is useful here as a strong contrast. The face is blended and rubbed and the coat allowed to fade out at the bottom of the picture

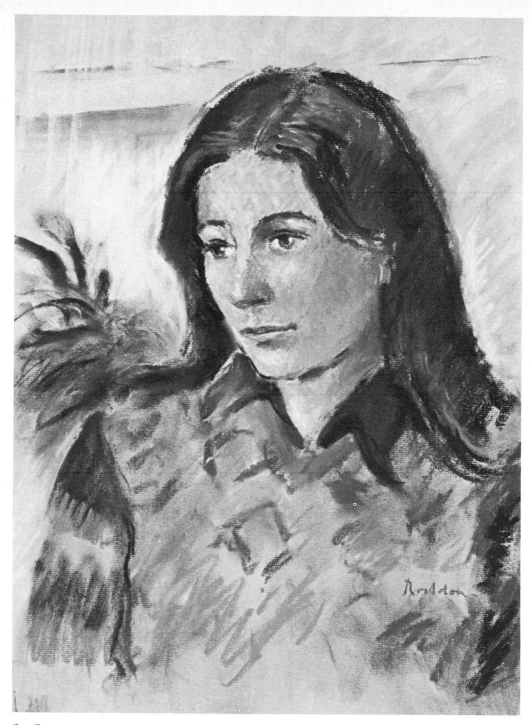

GUY RODDON

10 *Olive Parslow*

This portrait is treated much more freely
particularly in the handling of the hair,
the woollen cardigan and the suggestion
of a plant. Rapid strokes of a light chalk
on its side are used to soften and partially
cover the line of the dado on the wall
behind so that it is not too prominent in
the design

30

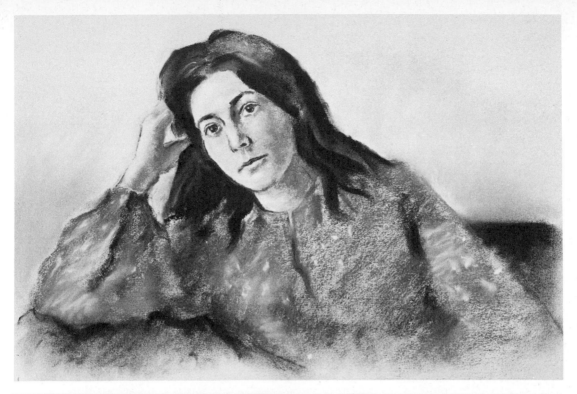

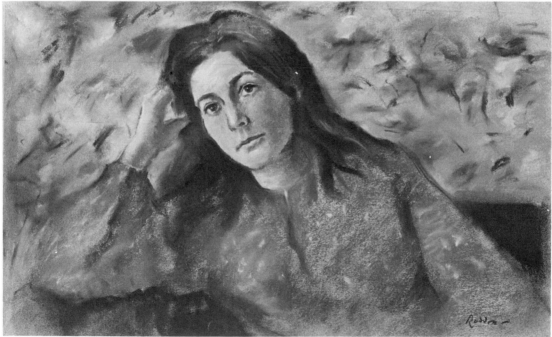

GUY RODDON

11 and **12** *Olive Parslow* two stages
In this second portrait of the sitter I have
tried to compensate for a rather tight
handling of the features by a variety of
softer and fused touches in the dress and
suggestion of wall paper pattern behind

31

LOUIS ANQUETIN 1861–1932
13 *Girl Reading a Newspaper*
The Tate Gallery, London, Copyright
SPADEM Paris 1978
This pastel is beautifully designed: the
composition being arranged in simple
areas of flat coloured shapes. The head is
in profile but the modelling is very subtle
and the form is explained without
detracting from the silhouette shape. There
is just the right amount of linear drawing
to contrast with the flat masses of colour
which are expressed by using the pastel
stick on its side. Some of the most telling
pastels are those which use simple means
as shown here. Anquetin worked in close
association with Emile Bernard and van
Gogh, who refers to him in his letters. His
painting, influenced by Japoneserie, a
major influence on artists at that period,
consisted of flat tones and unbroken
contours, as we see in this pastel

sittings. La Tour, however, like Degas after him, was known
to have worked slowly and with scrupulous care over each
stroke, taking many sittings over his work. Perroneau was
less exacting for his clients. It is worth quoting here a letter
from La Tour which sums up the difficulties and is some-
how reassuring in that he should have experienced also
what the beginner has to face. He is writing to the Marquis
de Marigny, the brother of Madame de Pompadour.

'Pastels, my Lord Marquis, involve a number of further
obstacles, such as dust, the weakness of some pigments, the
fact that the tone is never correct, that one must blend one's
colours on the paper itself and apply a number of strokes
with different crayons instead of one, that there is a risk of
spoiling work done and that one has no expedient if its
spirit is lost.'

It is worth noting again that many of the pastels of
Degas, seemingly so spontaneous, were the outcome of
drawings, drawn and redrawn on tracing paper so that
simplifications and corrections were made to produce the
final result.

So the pastel has to be planned in a systematic way, and
working from colours laid out on corrugated paper, as
already stated, arranged light to dark or warm to cool.
There is nothing more irritating, when one is in full spate,
to have to stop work and search for a missing colour, and as
quoted in the above letter one has to apply a number of
strokes with different crayons instead of one.

The best way to start the picture is to map out the shapes
carefully with a stick of charcoal and on completion blow
off the dust. A very good example of this method is the
beautiful pastel in the Tate Gallery by ANQUETIN of a girl
reading a newspaper. Here the silhouette shapes are clearly
defined, almost as a flat abstract pattern: the portrait is not
overmodelled so that the decorative quality of the work is
emphasized, but the face, seen in profile has just enough
subtle modelling to explain the construction yet not
destroy the decorative arrangement (13).

The artist may have used a key drawing: not necessarily
in charcoal, it may be executed in some neutral colour
which is then developed and incorporated into the final
design. I used this method in my study of *The Cafe in the
Arcades, Dieppe* (14 and 15).

An alternative method, in portraiture particularly, is to
make the character of the sitter the central feature relying
less on the overall pattern. Degas' *Mademoiselle Malo* (16)

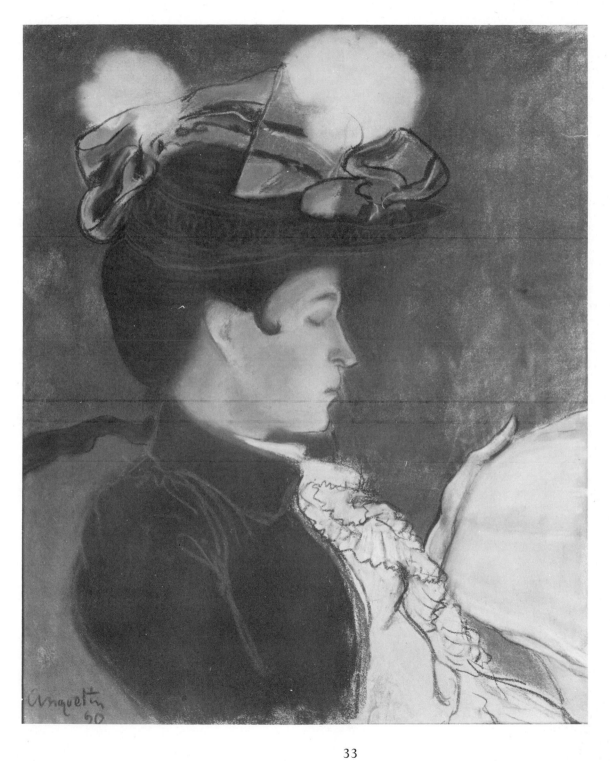

33

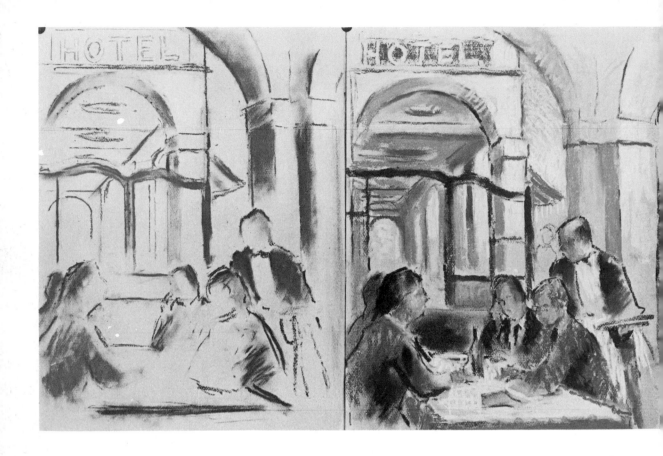

GUY RODDON

14 and **15** *The Arcades, Dieppe*
These illustrations show the three stages
for this picture. In the first illustration the
main lines of the composition have been
drawn in with terre verte pastel rather
than charcoal because I did not want the
drawing to be too fierce and the neutral
green grey colour married well with the
buff coloured paper. I used Ingres Canson
paper. The figures in the foreground have
been rubbed in lightly with the finger so
that at the outset I could move away from
line to tone and bring the figures in front
of the arcades behind. The architecture is
left rather more precise. Next, in the
second illustration, an attempt is made to
unite the group with the building behind

but at the same time keeping the pastel
strokes quite free and open. Finally I have
increased the tone under the arch and
also deepened the tone of the sky in order
to further relate figures and background
hoping to reduce the height of the picture
in case it was disproportionate to the
group of figures. A further problem was to
give just the right amount of suggestive
detail without overdoing it. The original
idea came from a jotting in a sketch book
accompanied with colour notes. I also
took a photograph, but hardly made use
of this and the waiter was not in the
photograph but put in the picture to
repeat the curve of the arch over the
arcades

34

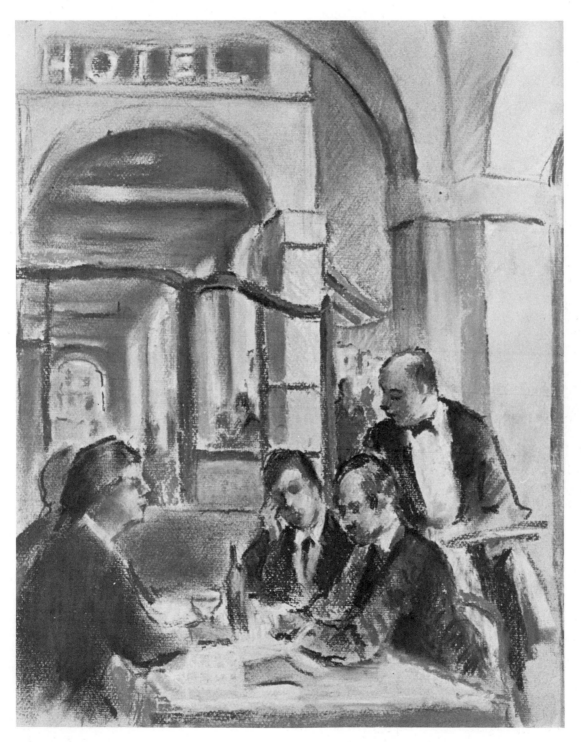

35

EDGAR DEGAS 1834–1917
16 *Mademoiselle Malo*
The Barber Institute of Fine Arts,
The University of Birmingham
This fine head by Degas is interesting for
its combination of pastel techniques. The
head is treated quite tightly; more of a
drawing than a pastel head and the
shading is expressed by diagonal strokes of
the crayon. The hat and the hair are
rubbed and fused into the background and
are softer and less precise than the
drawing of the features, whereas the figure
is expressed by broad vigorous strokes of
the pastel stick laid on its side. Finally the
background is put in very freely and in
places has obviously formed a paste – a
détrempe a la colle – having probably
been sprayed with steam from a kettle, as
explained in the text. (See page 46).

The flatness of the picture surface has
to be respected: this treatment is quite
opposed to the idea of a picture being a
window onto the world. Degas had a
hatred of *trompe l'oeil* and wanted to
destroy this illusion. This, I feel, is the
explanation for the treatment of the
background to the left of the head; it does
not recede behind the head as it does
beyond the hair, but is brought forward
to the picture plane. Space is implied by
the contour line describing the right cheek
of the sitter.

Degas' aphorism, 'the air that one sees
in the Old Masters is never the air that
one breathes' explains his thinking in the
working of this pastel

is a good example of this approach; it is a magnificently
vigorous pastel portrait which I shall refer to again since it
is most interesting technically, but here we may note
especially the broad sweeping strokes made by the pastel
held on its side which are contrasted with the tighter
drawing of the face. (See opposite.)

The lay-in of the pastel can be summed up under the
following headings.

(a) Charcoal drawings heightened with pastel
The charcoal is used for the heavy outlines and edges of
forms and for mapping the shapes. It can then be height-
ened with pastel and there are a number of drawings of this
type by Degas. This may be the best method to start with; a
picture that really amounts to a drawing tinted with pastel,
where it is useful to add to the form. The paper will play an
important part in this type of drawing.

(b) Charcoal and pastel
The charcoal drawing is incorporated into the pastel and
the more the pastel develops the less important the charcoal
stroke becomes. If the design becomes slack and needs
crispening and more definition, the charcoal can be used
again at a later stage.

A good example of the use of charcoal, where it has an
importance in its own right and a major part to play in the
design of the picture, can be found in the work of Eric
Kennington. His powerful drawings are drawn in charcoal
with a strong outline. Kennington, who was a sculptor,
gives to his drawings a quality suggesting that the form
may have been carved out of some hard and resistant
material. The modelling in the portrait of Lord Halifax (17)
has just this quality and the charcoal line, emphasizing the
contour of the forehead, and the treatment of the coat, adds
to the sculptural and very solid treatment of the sitter.

Kennington's illustrations to Lawrence's *Seven Pillars of
Wisdom* are useful for the student who is attracted to the
vigorous and rather hard type of pastel portrait which is
typical of his work.

The hard uncompromising approach of Kennington,
although not to everybody's taste, is admirably suited to
the subject of war. This theme was beautifully realized by
Paul Nash whose pastels recording the terrible landscape of
the trenches at Passchendaele during the Great War, have a
mysterious and cruel beauty reminiscent of the poetry of
Wilfred Owen. I do not know if Nash's pastels were drawn
on the spot but the technique suggests that they were

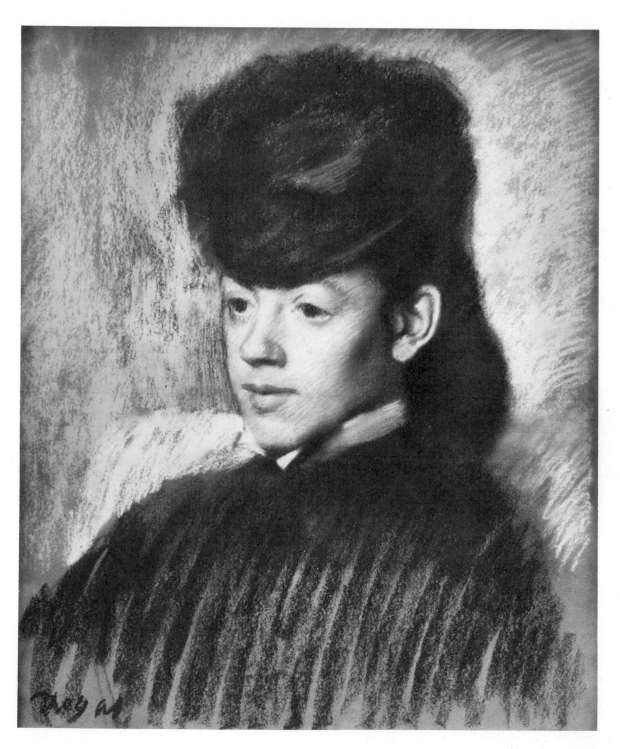

37

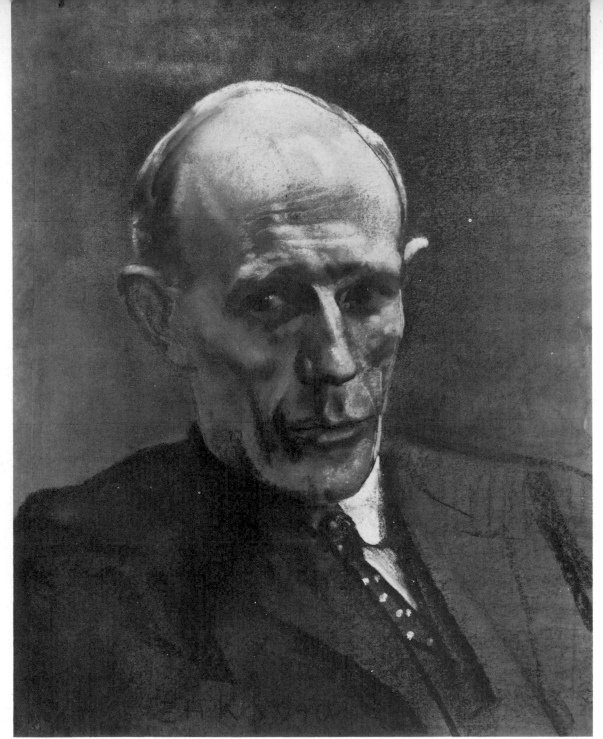

ERIC KENNINGTON
17 *Lord Halifax*
Imperial War Museum, London
Kennington, who was a sculptor, gives to
his drawings a quality suggesting that the
form may have been carved out of some
hard and resistant material. The

modelling here has just this quality and
the charcoal line emphasizes the contour
of the head, and adds to the sculptural
and solid treatment of the sitter. Both
these examples are in the Imperial War
Museum

38

drawn with hard pastels and possibly chalks and therefore more easily transportable. (See page 103.)

The pastel painting may be built up in a succession of undisturbed touches or the design may be developed with a few colours which are then blended with a stump or with the fingers. This, of course, results in a smooth surface which can easily appear slick if too much rubbing is used. On the whole it is better to vary the rubbed or blended touch with the more direct touch. Using both methods in the same picture gives a much wider range of effect.

Professor Constable in his book *The Painters' Workshop* tells us that La Tour used rubbing extensively while his contemporary Perroneau gave more prominence to the unfused touch. However, in the two self-portraits by La Tour which I reproduce, the example from the Dijon Museum (20) is very freely handled and contrasts remarkably with that at St Quentin (18 and 19) where the handling is tight and certainly blended.

From the key drawing the pastel may be built up with colour and tone. Broadly speaking the head is divided into light, half-tone, and shadow, with intervening tonal gradations. The modelling of the head may be expressed in a variety of ways.

(a) Modelling by tone

Nature expresses itself in terms of light and dark and the modelling, taking into account the way the light falls across the form, is made up of degrees of tonal gradations. The edge of the form may be expressed by a contour line or fused into the background. There is in fact no such things as a line in Nature, only the edge of a form, which is the contour line. The more finished of the La Tour self portraits relies more on tone than the other version which is reinforced with lines and modelled in colour by the planes.

The student should try to understand what is meant by *tone* and the relationship of *tone* to *colour*, since tone functions independently of local colour.

What, then, is tone? It is sometimes referred to as values from the French *valeurs*, words used to describe the gradations from light to dark. No picture is capable of reproducing the scale of the most brilliant sunlight of nature to the darkest dark. Using the analogy of the piano keyboard, the wide range from the lights to darks in nature have to be represented by a compromise using two

Developing the pastel after the first lay-in

39

MAURICE QUENTIN DE LA TOUR 1704—88
18 and **19** *Self Portraits*
The most important of the many
pastellists of eighteenth century France
and one of the greatest masters of the
medium. He was born at St Quentin where
the largest collection of his works are to
be seen. He went to Paris as a young man
and exactly mirrored the age of La
Pompadour with his pastels which
perfectly expressed the silks, satins, powder
puffs and scented fans of the rococo
period. Degas collected his pastels and was
heartbroken when, after the bankruptcy
of his brother's firm, he had to sell them.

These two self portraits from St
Quentin and Dijon respectively illustrate
his tight and free handling of the medium.
In the first the transitional tones are
blended to give a uniform surface, while in
the second portrait the pastel strokes
follow the planes of the head and are left
undisturbed resulting in greater vivacity of
handling

19 Detail of **18**

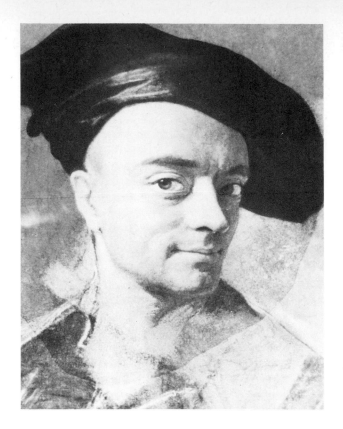

LA TOUR
20 *Self-Portrait*
Dijon Museum
By keeping the pastel strokes open and
free, La Tour has modelled the forms of the
face by the planes. The pastel is put on
thickly as an impasto on the near cheek,
A, then lightly and thinly applied as a half
tone below the cheek bone to the jaw, B;
the pastel has been gently blended where
the mouth tucks into the cheek as also
over the left eye, C. The liveliness of
handling owes much to a combination of
blended strokes with open strokes which
move in the direction of the form. The
highlights are reserved for the lower lip,
the form under the corner of the mouth
and the creases of the cheek, where they
suggest a smile.

The light tone on the right side of the
face, D, serves as a contrast and prevents
the far side of the face getting lost in the
general tone of the background. The
touches of drawn line on the nose, above
the nostril, and under the jaw, bring the
whole thing together

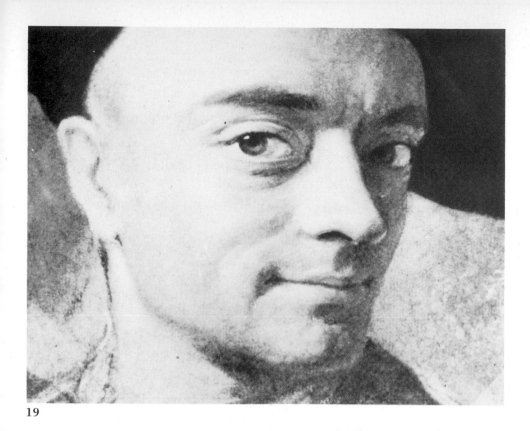

19

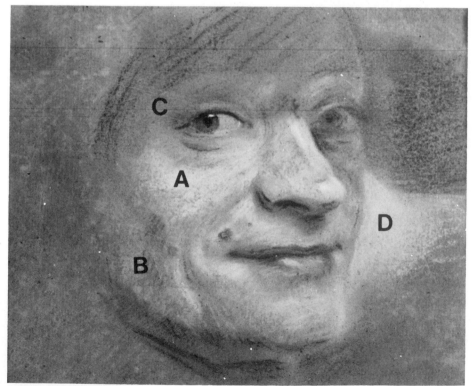

41

HENTRY TONKS 1862–1937

21 *George Moore*
The National Portrait Gallery, London
How well Tonks has caught the strange
quirky character of the Irish writer and
critic, who also sat to Manet for a notable
portrait. Sir William Rothenstein drew
him as well and explained how Moore's
pastime was talking!

'Oh Rothenstein, I am so glad you have
come, I can only think when I am talking.'

One wonders if he talked when he sat
for this portrait by Tonks. The head is
delicately observed and subtly modelled
and the flourish of the strokes and
vigorous drawing of the lower part of the
figure seem to rescue it from being
illustrative and sentimental

or three octaves instead of eight if that is not stretching the
analogy too far.

In order to understand this, it is suggested that simple
exercises are devised, involving the division of a long
narrow rectangle into five squares with the light tone at one
end and the dark at the other. The middle tone (square 3)
is the half-way mark between these extremes and also the
colour of the paper and the squares should be filled up with
a neutral grey, moving from black to white. A further chart
may include more squares – perhaps eight to give a wider
range. When these two columns are complete it is
suggested that a colour, such as red or blue, are gradated
tonally in a further two columns and in association with
the tonal range of the neutral black white columns. The
best way to determine the tone value of the colour is to
look at it through the lashes of half closed eyes.

(b) Modelling by colour and line
Tonal modulations were discarded for colour modelling by
the Impressionists, notably Renoir, who used colour to
express form. This method is based on the theory that warm
colours tend to advance and cool colours recede. And the
movement from light to dark is expressed by orange yellow
in the lights to complementary blue violet in the shadows.
In cases where the shadows are warm, one moves from
warm flesh colour in full light to warm shadow via a half-
tone transitional passage of grey to green grey.

An alternative method to fusing these colours is to build
up the picture with alternate cross hatchings of warm
colour over cool colour. Degas caused colour to vibrate by
using small superimposed touches of opposing colours
arriving at a richness of effect, and at the same time avoid-
ing the extremes of over brilliant and garish colour that
pastels can be in their natural state.

His method, described by Douglas Cooper, was first of
all 'to make a pastel, or pastel and charcoal drawing with
heavy outlines in rather strong colours. This he fixed in the
normal way: but then, defying the practice of earlier
generations, he continued working in pastel over this base,
imposing one layer of colour on another, each in turn being
fixed, until at the end when he had achieved his desired
effect, his sheet was covered with quite a heavy impasto.
However whereas a glaze of oil paint can be applied evenly
and thinly, Degas could not do this with pastel, so that in
order that the underlying colour could show through he
was obliged to apply the subsequent layers of colour

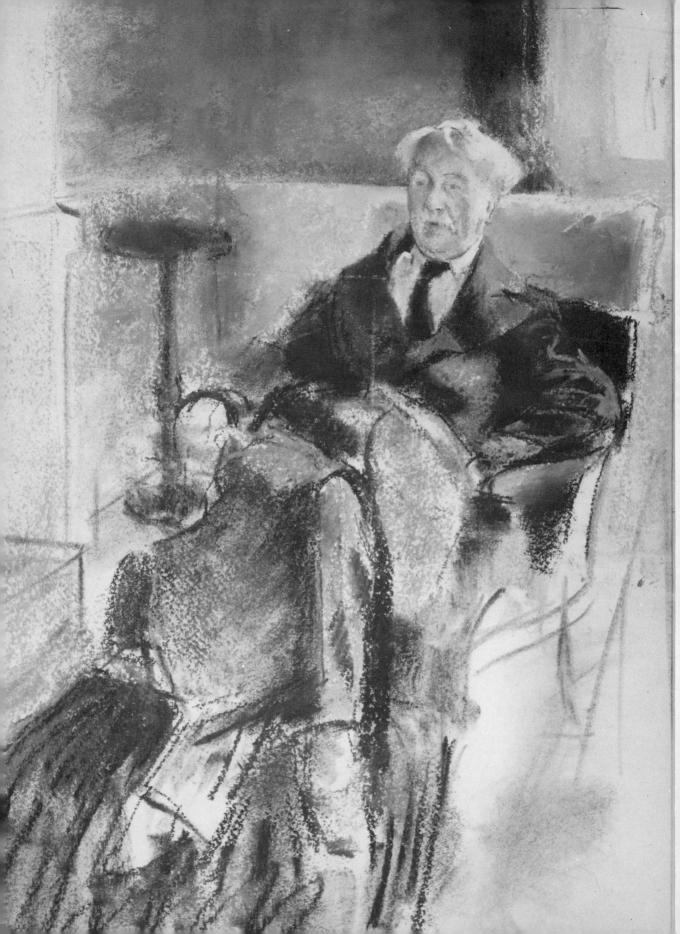

EDOUARD MANET 1832–83

22 *George Moore*
The Metropolitan Museum of Art,
New York
The H O Havemeyer Collection,
Bequest of Mrs H O Havemeyer 1929
One of the finest pastels of the nineteenth
century which shows off Manet's virtuosity
and brilliant technique. It is drawn in
with such panache, successfully capturing
the distant expression, yet mobile face.
The artist rarely uses a half tone, relying
for the modelling on the opposition of
light and dark and the drawn contour

irregularly and this accounts also for the rugosity of the surface texture of many of his late works.'

The cross hatching of course gave him greater freedom of expression.

As for Degas' colour, there is an amusing story told by Vollard, the picture dealer, who was asked by another painter to find out from Degas 'where he gets those shades that no one else can obtain'. When Vollard went round to the studio, the painter happened to have a box of pastels in his hand and was spreading them out on a board in front of the window. 'I take all the colour out of them that I can by putting them in the sun.' 'But what do you use to get colours of such brightness?' 'Dead colours, Monsieur,' he replied.

The flesh tones may appear hot in pastel and this may be avoided by laying in light bluish or greenish tones and continually balancing the warm and cool colour values.

Manet's method was in general more direct as we see in his pastel *At the Café* (56) in the Glasgow Art Gallery. Like his oil painting Manet uses a high keyed scarcely modulated flesh tone of flat tints plus a surrounding contour line: in some cases the features are put in on top of this with the drawn line and left unblended. The fine portrait of George Moore (22) in the Metropolitan Museum of Art, New York, is a case in point.

The student should experiment with all these methods. When reinforcing the modelling with a contour line it is well to remember that this may disappear in places, where it merges with the background and reappear in others. The writer recalls, as an art student, an amusing formula given by one of the masters. 'Lost and Found', he used to say.

Some pastel and oil portraits suffer from over modelling. They stand out uncomfortably from the page as *trompe l'oeil*. One should preserve the flat plane of the paper.

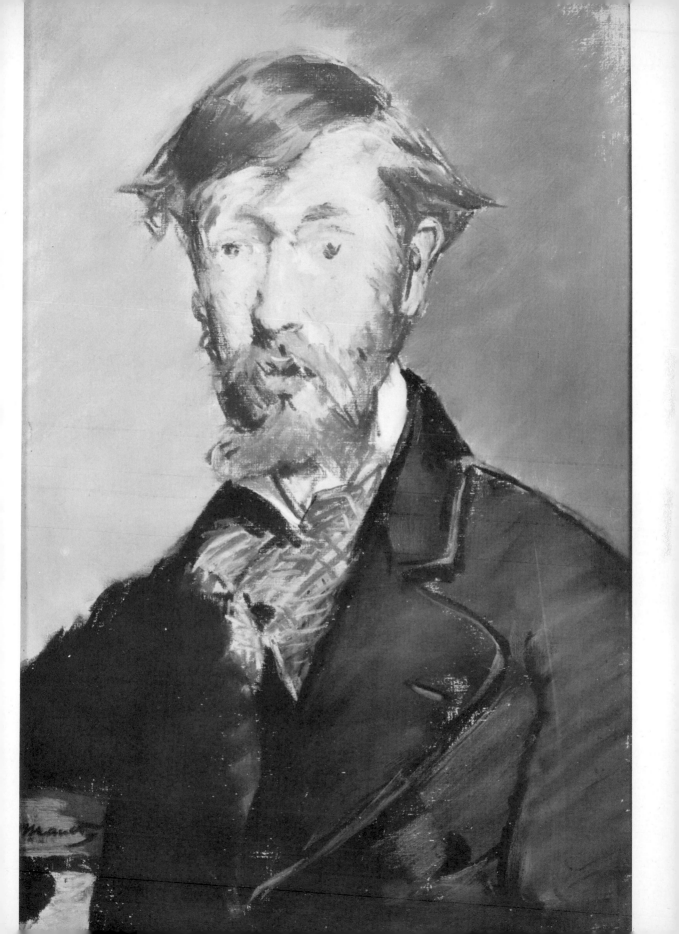

Mixed media

Pastels are often used with other media. These are:
- Pastel with watercolour
- Pastel with gouache
- Pastel with distemper paint
- Pastel over monotype

When using the water colour, the design may first be laid out in simple washes of water colour which can be very effective and has the advantage of not destroying the surface of the support. There are many examples of this combination of media in the work of the Impressionists. It is particularly effective with landscape.

Pastel is equally effective when used with gouache. Gouache is an opaque water colour paint but has the defect of drying lighter in tone than oil paint which it in some ways resembles.

Interesting results may be obtained when oil pastels are combined with water bound paints such as the above. Here the water colour or gouache is repelled by the oil in the pastel or the wax in the crayon, if used, and globules of paint give an interesting surface to the picture. Henry Moore's shelter drawings have this effect but it may become a trick when too liberally employed.

Distemper paint — *détrempe a la colle* — was used by Degas. The colour was mixed with size while heating and applied hot to the canvas. As Denis Rouart tells us in *Degas: a la Recherche de sa Technique* he layed in his subject in pastel and then sprayed boiling water over. 'This made the dry pastel into a paste. He worked into this paste with brushes of varying stiffness. If the water onto a thin layer of pastel, the result was more like a wash which could be spread with the brush. He took care not to spray the water vapour all over the picture, so as to keep the original surface of the pastel where he wanted to give it variety.'

What has happened here is that the pastel has in part turned into a painting which with the graphic work gives plenty of variety. Degas, as can be seen, was always experimenting with pastel and extended the resources of the medium far beyond the traditional methods of the eighteenth century French pastellists.

The monotype over which Degas sometimes continued in pastel, is a single print made by painting in oil on a copper plate and printed on paper in the normal way and it has quality of texture caused by the pressure of printing and differing from painting direct on paper.

ELGAR DEGAS 1834–1917
23 *Miss Lala at the Cirque Fernando* 1879
The Tate Gallery, London
A preliminary pastel study for the large picture of the same subject. There are some figures at the bottom right hand corner of the picture which are clearly measurements for squaring up. This is a very free and lightly sketched pastel, in contrast to the many that were built up with successive layers and fixed between the layers. From the point of view of drawing it is quite masterly in its observation of the pose, of the weight of the body hanging by her teeth and the way the tent has been delicately suggested beyond the figure

46

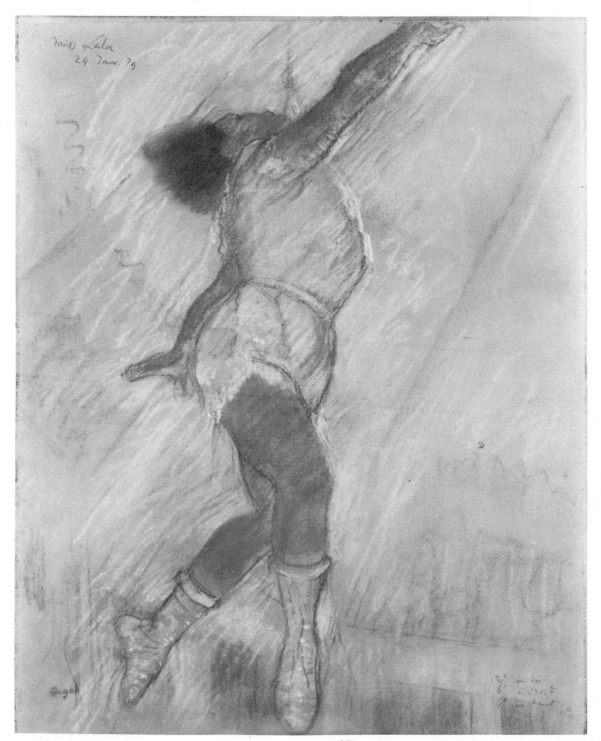

47

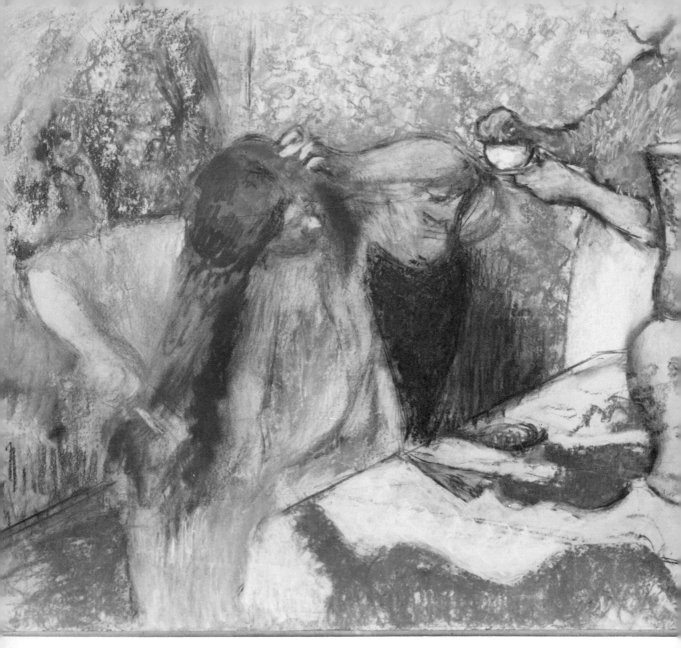

Elgar Degas 1834–1917
24 *Woman at her Toilet* 1894
The Tate Gallery, London
A later and more developed pastel. It is
said that Degas relied more and more on
pastel in later life because of failing
eyesight. The suggestion of the model
combing out the weight of her rich hair is
the sort of rapid movement that pastel, as
a medium, expresses so well. But here it is
particularly interesting to see the variety
of textures and marks that Degas is able
to achieve with the pastel stick

Fixatives

The arguments for and against the use of fixatives for pastel are plentiful and in our day there are many painters who are against the use of fixatives as those who favour its use. The chief objection is that the pastel loses brilliance after being sprayed with fixative.

It was a matter of constant research in the eighteenth century. La Tour wanted to be certain of the permanence of his work and had long discussions with friends from the Academy of Sciences in his search for a fixative that did not alter the bloom of the picture. Loriot's method for La Tour was to apply a mixture of fish glue and spirit of wine diluted with vinegar to the back of the canvas. It is assumed that he may have used isinglass, a superior grade of fish glue made by washing and drying the inner layers of the bladder of the sturgeon: but the ultimate recipe died with La Tour as also the recipe used by Degas for the successive stages of his work.

If the artist wishes to fix his work, he may choose one of the following methods:

1 To fix from the front using a mouth spray or a commercial aerosol type alliance.

2 To fix successive layers, leaving the last layer untouched.

3 To fix from the back, which combines a fixing and mounting process when the pastel is pasted to a card or mounting board and the paste soaks through the paper fixing the powder from behind.

Most commercial fixatives, such as those used for charcoal drawings are diluted solutions of shellac in a volatile liquid. Max Doerner recommends as the best, because it is the whitest and does not stain, Dammar dissolved in benzine. Some shellac or mastic based commercial fixatives may stain and are not always transparent and Doerner suggests that fixatives should be of the rapidly evaporating type. Doerner and Ralph Mayer should be consulted for studio prepared recipes.

Arguments against fixing can be summarised as follows.

1 The colour loses brilliance and darkens in tone if oversaturated. The reason for this optical change is that when fixed the particles of pigment rearrange themselves as they absorb the fixative.

2 The pastel then becomes a distemper painting, such as used in stage scenery, as the particles become thick and heavy like a paste. The word pastello (paste) is the origin of the term pastel.

3 The picture darkens in tone and loses its light and airy quality.

4 Durability will be in inverse proportion to freshness.

When spraying fixative one should not stand too close, blowing the fixative over the pastel in the form of a light mist. If there is too much wetting, blobs of the liquid may round down the drawing and if not sprayed evenly ridges may occur which can be very noticeable. One should not start spraying the picture immediately from the front but move slowly from the left, beyond the picture and direct the spray evenly across the surface to the right of the picture. Care should be taken that drops from the nozzle or atomizer do not fall on to the paper and cause surface marks. Practice on unwanted drawings will determine the right distance to stand when spraying.

It is thought that pastel fixes itself automatically in course of time because of the moisture in the atmosphere which acts on the size in the paper and the gum in the pastel. The older a pastel is the more solid it becomes. (Moreau-Vauthier *Technique of Painting*.)

Certainly, with time, the moisture in the atmosphere may cause 'foxing', and a 10 per cent solution of formalin may be brushed over the ground to prevent the spread of the fungus, and if the pastel sticks are made in the studio a mild solution of formalin may be included in their composition.

Because of their fragility great care should be taken with the handling of pastels and particularly with those pictures which are not fixed. Vibrations and knocks may dislodge the powder. Therefore mounting and framing should be considered next, and the glazing of the picture is as important as the fixing, and the picture must be framed separated from the glass and if the support is canvas the stretcher must include a protective board at the back.

A method of mounting a pastel and at the same time fixing it is included in the illustrations 25 to 31. Here the pastel is laid face down on a sheet of thick glass and attached to it at the corners with *Sellotape* or Scotch Tape. Great care must be taken to see that there is no lateral movement which will remove the pastel onto the glass or smudge the surface. The back of the sheet of paper is then thoroughly soaked with paste, applied gently with a soft brush working from the centre outwards to the edges. The card is then lowered on to the back of the sheet and weights in the form of heavy books placed on the back of the card. To counteract the uneven strain and pull of the drawing when stuck to the other side, the card should have a sheet of wrapping paper pasted to the back. When dry the card with the drawing now fixed to it is lifted off briskly to avoid smudging.

This method, recommended by Jack Merriott, is not as complicated as it may read, but does require rehearsing with pastels which are less successful than one's good ones and are no great loss if spoilt in the process. The card should be the same size as the drawing or, if not, trimmed on the guillotine.

A further method is suggested by Ralph Mayer. Here the pastel is laid face down on a smooth card and the back of the pastel is dampened with a well-rung sponge. A half-inch margin around the edges is blotted dry and applied with paste. It is then placed face up on the mount, which should be somewhat larger than the paper, covered with sheets of smooth paper, rubbed flat with the hand and covered with heavy weights until dry. The pastel paper should stretch out tight and smooth.

Mounting and framing the pastel

51

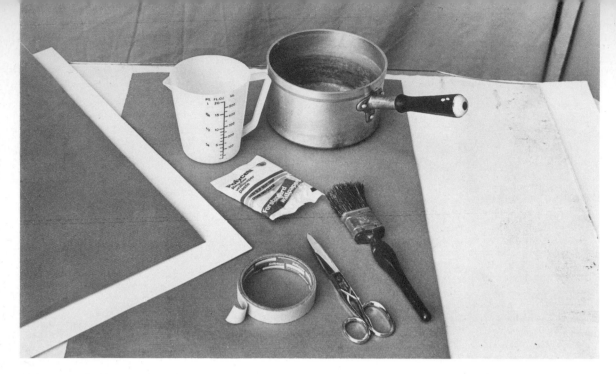

25 Materials for mounting the pastel, showing card, wrapping paper, Polycell paste, etc. For method, see page 51

26 Preparing the paste

27 The pastel is laid face down onto the sheet of glass

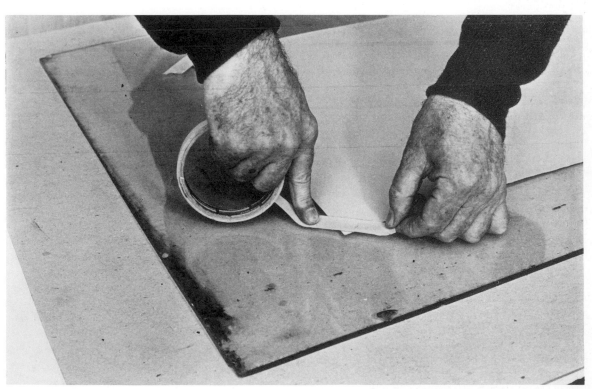

28 The corners are Sellotaped to prevent movement

53

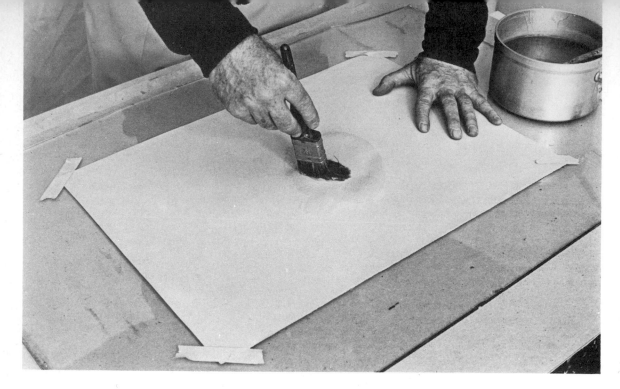

29 Paste applied to back of drawing

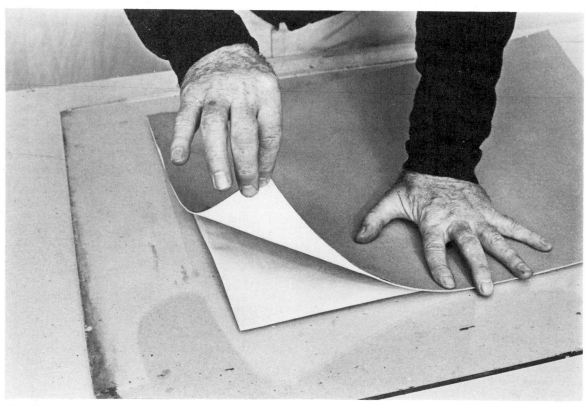

30 Lowering the mount on to the pastel

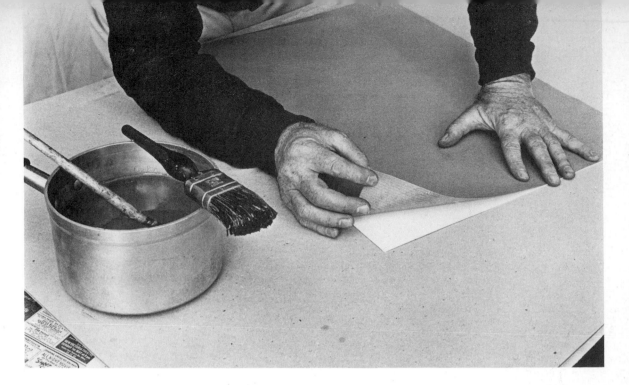

31 Packing paper is pasted to reverse side of card

Storing pastels

The best way, but the most expensive, is to frame pastels. But until they are required for framing they should be stored away carefully flat down in the shelves of a plan chest but not in a portfolio. They should be separated from each other by a sheet of greaseproof paper, cellophane or tissue. A heavy board laid over the pile will protect them from any lateral movement and should press the grains of pastel more firmly into the texture of the paper if the loose particles of the unfixed pastel are tapped off before removal from the drawing board. One should tap the corner of the drawing board to do this. Then when the pastel is put away the pressure of weight should not affect the surface.

Although one associates the medium with France, the pioneer, curiously enough, was an Italian ROSALBA CARRIERA (1675–1758). She was a Venetian and one of the few women artists to have achieved fame before the nineteenth century. With the help of her patron Crozat, she conquered Paris and had a tremendous vogue under the Regency of Louis XV, and in her native Venice she attracted the attention of English Tourists. Horace Walpole writing of FRANCIS COTES compares him to Rosalba, whose fame had now spread over Europe. Her pastels are distinguished by their softness and light touch due to the eighteenth century practice of rubbing and smearing the pastel over the surface of the support.

After her death the stage is occupied by MAURICE QUENTIN DE LA TOUR. He was born at St Quentin in 1704 and went to Paris as a young man. His witty portraits exactly mirror the rococo age of silks and satins and he was a formidable technician. His first pastel was of Voltaire; thereafter his sitters included Louis XV, Madame de Pompadour and most of the fashionable world of his time. His sketches are often more interesting than his finished portraits and there is no finer example of this than his portrait of his mistress, the opera singer Mademoiselle Fel, the original of which can be seen at the Museum in St Quentin.

Pastels, which at the outset of Quentin's career were never taken seriously and were considered an inferior and fugitive medium, had become an absolute craze towards the end of his life and, whereas there were few pastellists working in Paris at the start of his career, by 1780 there were 2500 working in the capital.

JEAN BAPTISTE PERRONNEAU (1715–1783) was the only serious rival to La Tour and after 1755 his popularity caused him to travel extensively all over Europe. He died in Amsterdam. His *Girl with a Kitten* is in the National Gallery, London.

CHARDIN (1699–1779), one of the greatest of French painters and a master of still life and genre subjects, which reflect the interest in Dutch painting popular in France at the time, excelled even La Tour in his pastel portraits. They have a breadth of vision and technique and a simplicity

and understanding which contrasts with the more fashionable work of the period.

The father of English pastel painting was FRANCIS COTES (1726–1770) who was described as a 'Reynolds in chalk'. Horace Walpole said of his work: 'If they yield to Rosalba's in softness, they excel hers in vivacity and invention.' He painted Queen Charlotte. His most interesting pupil was JOHN RUSSELL (1745–1806) who wrote a book *The Elements of Pastel Painting* generously describing his technical methods. He rubbed his paper, steel blue in colour and similar to La Tour's ground, with pumice powder. This he attached to a canvas with gelatine. He knew REYNOLDS and Dr Johnson and his circle, and was made an associate of the Royal Academy at the age of twenty-seven. He painted a series of pastels for King George IV and was also patronized by the Prince Regent. Examples of his work in the Brighton Art Gallery include a portrait of the clerk to the kitchens found in the cellars of the Brighton Pavilion and a lively pastel of John 'Smoker' Miles who was a bathing attendant at the resort.

Russell in his book gives a very full account of eighteenth century practice. He used spirits of wine as a binder and points out that white lead, satisfactory when protected by oil, tends to turn black in pastel. His contemporary DANIEL GARDNER (1750–1805) combined pastel with water-colour and gum into a 'mysterious gouache'. He was a friend of Romney whose style is somewhat like his own. His method also included 'crayons scraped to dust' mixed with brandy and spirits of wine (see Whitley, *Artists and their Friends in England*).

Pastels seem to have lost popularity after the turn of the century until their revival in France by DEGAS, MANET and the IMPRESSIONISTS, whose methods are described elsewhere in this book. Indeed the French masters of the period opened up the possibilities of the medium with a wider range of expression than the production of fashionable portraiture.

The fused touch gave way to a more direct approach or, with Degas, variations in which rubbing and direct touches are combined. RAFFAELLI, the Impressionist painter invented a soft pastel, similar to an oil pastel and Degas experimented with various media as never before.

In England the revival dates from 1880 when the Pastel Society held its first exhibition at the Grosvenor Galleries. Members and others who established a tradition for the

ROSALBA CARRIERA 1675–1757
32 *Jeune Fille Tenant un Singe*
The Louvre, Paris
As with the Perroneau portraits, it appears fashionable to paint children with their pets. This is a delicate yet striking portrait which is particularly compelling for having a dark background. The floral arrangement in the hair is repeated with a spray that she is holding in her hands and adds to the charm of a portrait which otherwise might be too severe. Rosalba was the pioneer of the medium

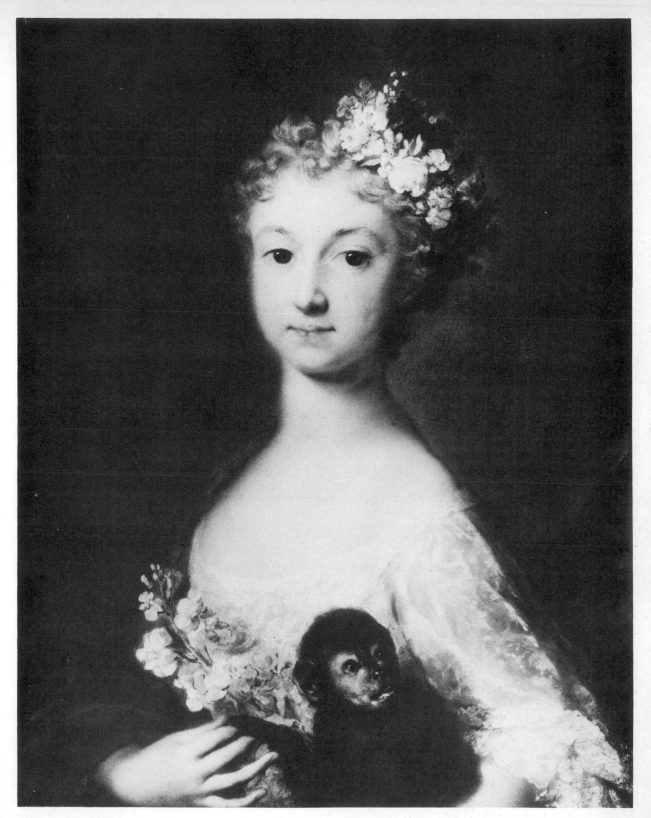

59

medium included WATTS, BRANGWYN, WHISTLER, TUKE and SARGENT.

Some of the most interesting work was executed by Nash and Kennington as War Artists, and Kennington's illustrations to TE Lawrence's *Seven Pillars of Wisdom* are justly famous. Modern practioners include ROBERT BUHLER RA and WILLIAM DRING RA.

MAURICE QUENTIN DE LA TOUR 1704–88
33 *Madame De Pompadour*
The Louvre, Paris
This magnificent portrait was
commissioned in 1751 by the Marquis de
Marigny, brother of the sitter. In this full
length sitting portrait, La Tour, with a
formidable technique, has given us an
incredible amount of detail with great
freedom of handling and expression. It was
first shown in the Salon of 1755, placed
on an easel behind a balustrade, as
Adrian Bury tells us. Chardin persuaded
La Tour to accept 24,000 livres, which the
sitter had sent him, instead of a price
double that amount which the artist had
demanded

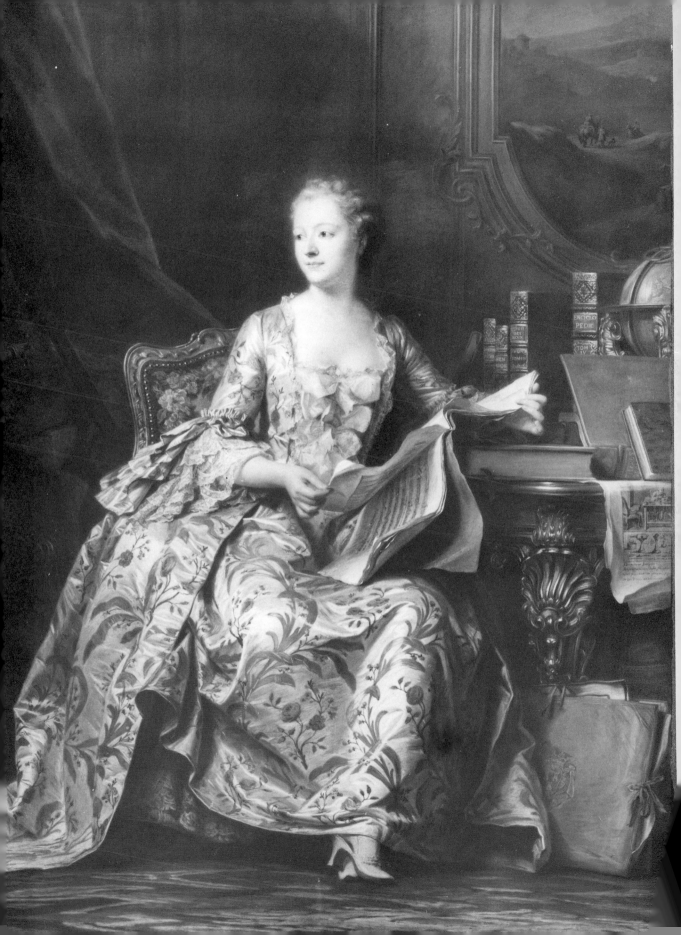

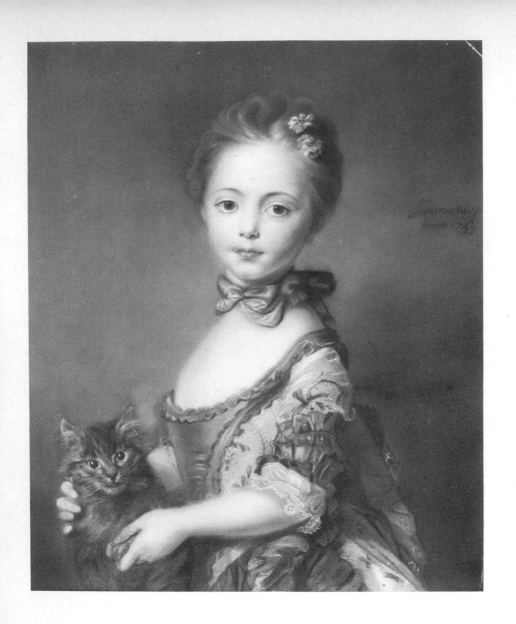

JEAN BAPTISTE PERRONNEAU 1715–83
34 *Girl with a Kitten*
The National Gallery, London
Perronneau was a much sort after French
portrait painter who travelled all over
Europe and was the chief rival to La Tour
as a pastellist in the eighteenth century.
This charming pastel reveals the innocence
of childhood and is also a sympathetic
study of a kitten. Pastels of this sort
became an absolute craze in the France of
his day and it is said that by 1780 there
were two thousand five hundred pastellists
working in Paris

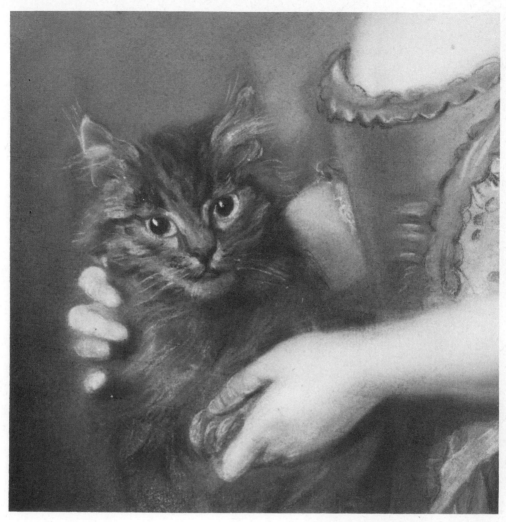

35 A detail from this picture where the painter, who seems strangely constrained in his handling of the portrait of the young girl, has allowed himself greater freedom in his treatment of the kitten, even though it has something of a fixed expression

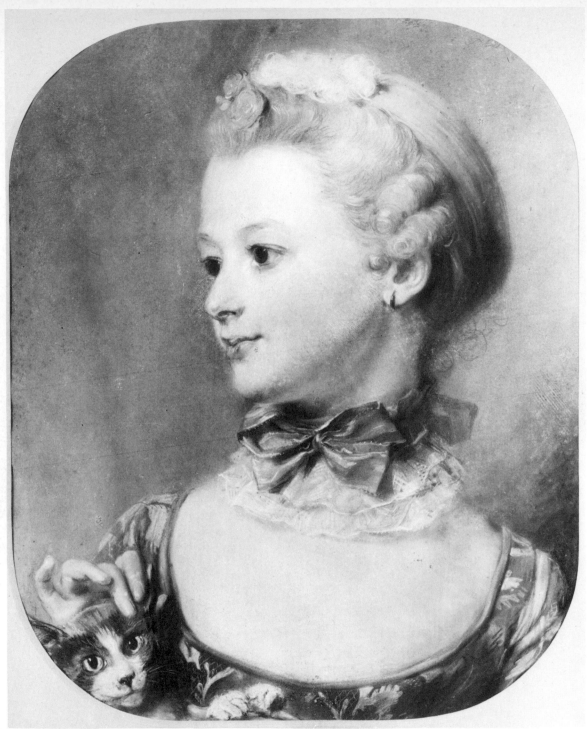

JEAN BAPTISTE PERRONNEAU 1715–83
36 *Girl with Kitten*
The Louvre, Paris
In this pastel there appears to be less
rubbing and more evidence of the pastel
strokes. The silk bow and lace around the
neck are beautifully and sensitively
expressed and the total effect is softer than
the example in the National Gallery

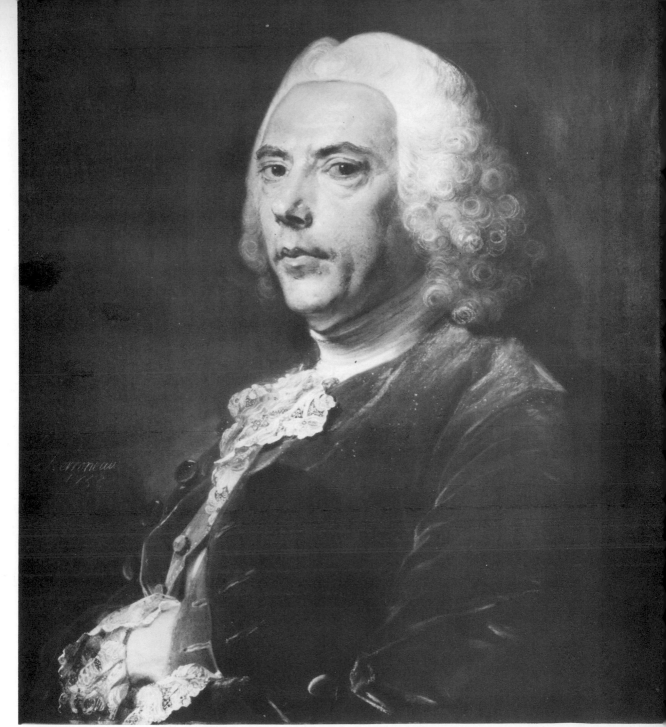

JEAN BAPTISTE PERRONNEAU 1715—83
37 *Pierre Bouguer*
The Louvre, Paris

A fine portrait showing a remarkable feeling for character. The perruque, where it crosses the forehead suggests weight and solidity and at the same time the velvet coat, which is well filled by this impressive sitter, and the lace cravat and cuff, are expressive of their different textures

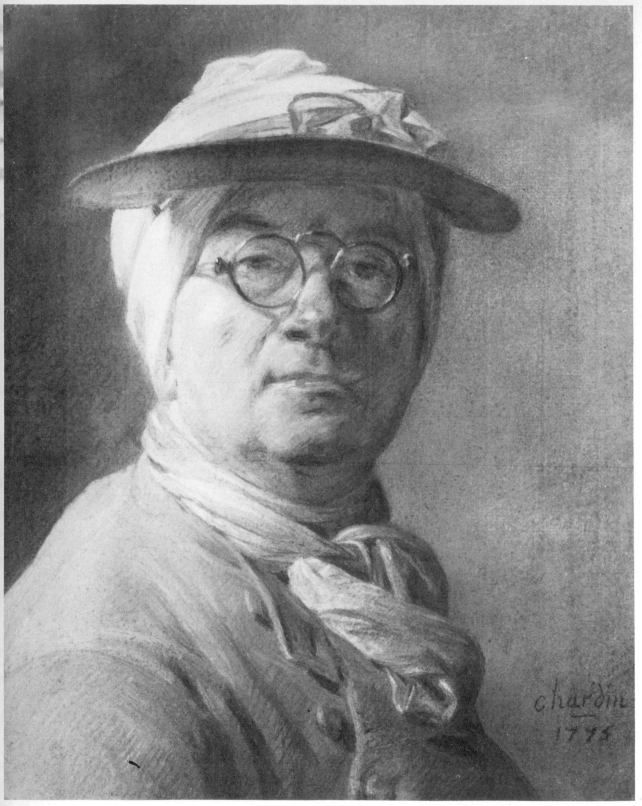

66

JEAN BAPTISTE SIMEON CHARDIN 1699–1779

38 *Self-portrait*

The Louvre, Paris

Chardin was one of the greatest of French painters, who in a rococo age painted still life and genre pictures which carry on the tradition of Dutch and Flemish art. His work is truthful, ruthlessly realist and has great breadth of vision and, in some cases, compares favourably with a Rembrandt. However, he turned to pastels late in life when his eyesight troubled him and exhibited two self-portraits and a portrait of his wife in the Salon of 1775. These are now in the Louvre. Cézanne wrote: 'Do you remember that fine pastel of Chardin in spectacles with an eye shade jutting out above them? This painter was as cunning as a fox! Have you noticed how, by means of light, transversal lines across the nose, he brings his values into clearer focus?'

These pastels surpass and are more profound than the fashionable work of La Tour, which is not to deny the skill and quality of La Tour's work

FRANZ-JOSEPH PFEIFFER 1791–1807

39 *Marie-Caroline Deckers*

Collection of Baron André de Moffarts

This pastel is included as an example of the type of pastel portrait often to be found in family collections by professionals who travelled across Europe in the eighteenth century earning their living in this way. The medium had become very popular for family portraits such as this pastel by Pfeiffer, which is in the possession of a descendant of the sitter

67

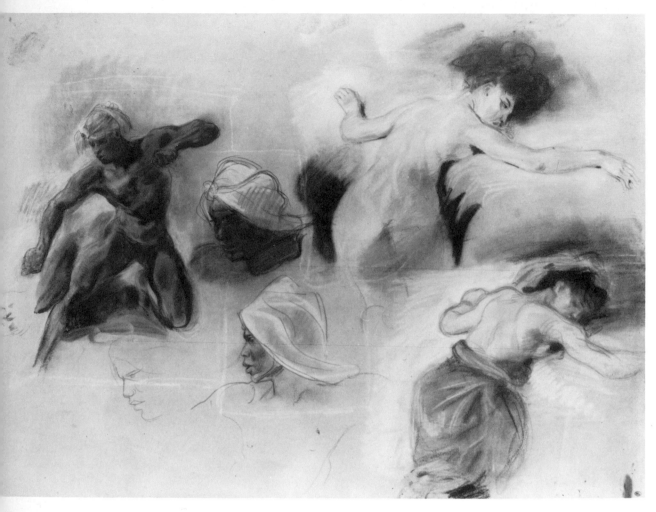

EUGENE DELACROIX 1798–1863

40 *Study for the Death of Sardanapalus*
The Louvre, Paris

Delacroix is known to have made a
considerable number of studies in
preparation for his large scale paintings.
In these he carried out his researches
into composition and colour harmonies
and they give an interesting clue to his
thinking.

This pastel is one of the many studies he
made for his Salon picture inspired by
Byron's play based on the Sardanapalus
theme.

In his large decorative pictures Delacroix
always admired the art of the theatre
scenic painter, who using distemper paint
arrived at a brilliance of colour that oil
paint, with its tendency to darken, was
unable to achieve.

Pastel allowed Delacroix to experiment
with chromatic harmonies that he was
looking for in the finished work and he
is known to have evolved a method of
working with pastels on fine canvas
which has been treated with size water
and allowed to dry. The picture, when
finished, was sprayed with hot steam to
soften the size and fix the pastel. This
should be compared with Degas' method.

68

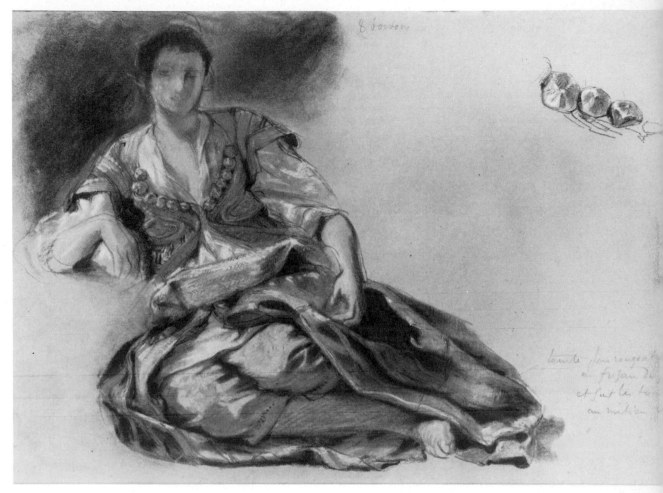

40 *continued*
The pastel in both cases turning into a
distemper paint.
This illustration, however, is a sheet of
studies including the nude at the foot of
Sardanapalus in the finished picture and
had the negro in front of her.

EUGENE DELACROIX
41 *Study for Femmes D'Alger*
The Louvre, Paris
A more detailed study used for working
out the rhythms and colour of the
costume

EUGENE DELACROIX
42 *Etude de Ciel, Crepuscule*
The Louvre, Paris
A beautiful study which brings Delacroix
close to the Impressionists who so much
admired him

Sir Edwin Landseer 1802–73
43 *Study of a Cow*
Laing Art Gallery
Newcastle upon Tyne
A fine pastel drawing. The drawing has a
great variety of expressive pastel strokes
from cross hatched shading to diagonal
shading

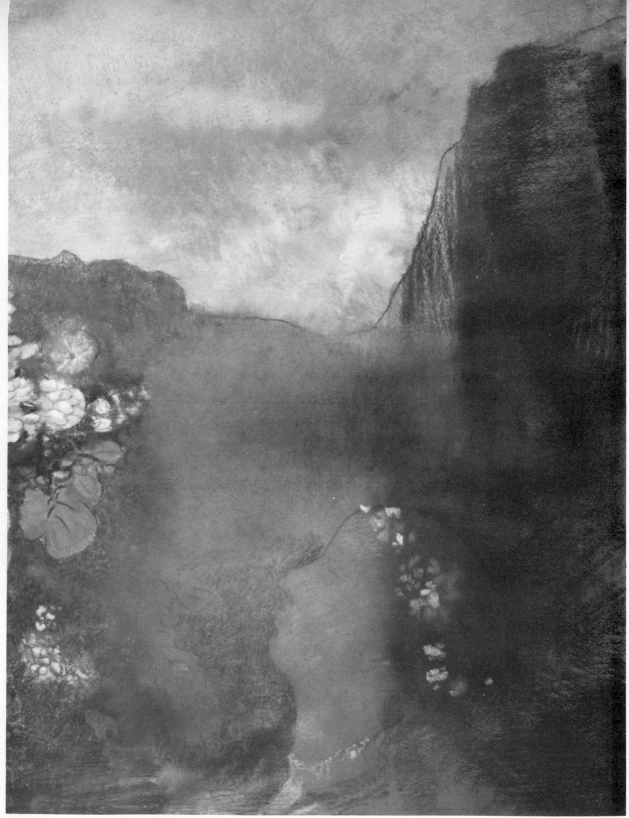

44 and **45** *Ophelia* Details
Please note that this painting is
landscape; the top is to the right
(caption on page 73)

72

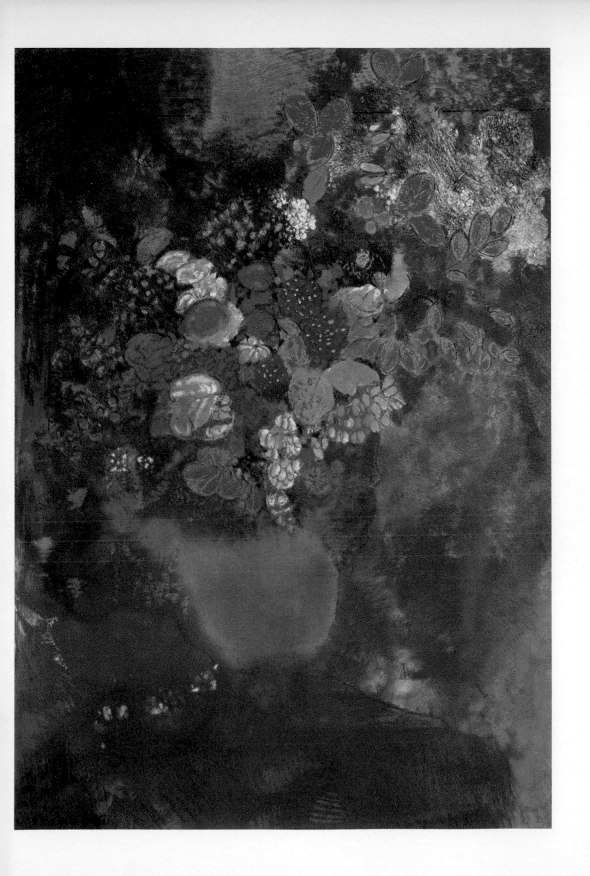

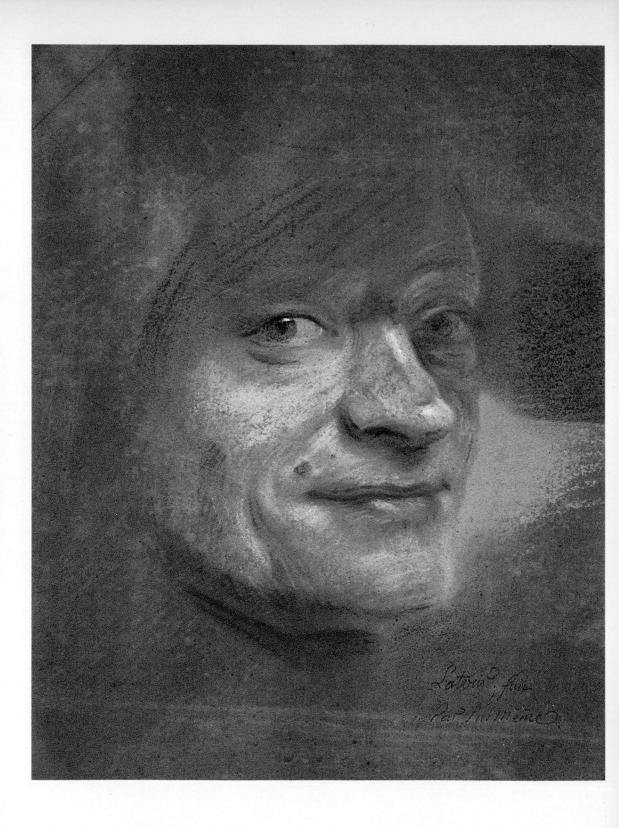

LA TOUR 1704–88
Self Portrait
See pages 40, 41 and 112

ODILON REDON 1840–1916
Ophelia
The National Gallery, London
[Colour plate facing page 72]
The National Gallery have recently
acquired this fine pastel and it hangs
alongside the work of major post-
impressionists and has an authority and
impact so that it holds its own very well
among the oil paintings. This seems to
give the lie to the medium being
lightweight. It is chosen, though not to
everybody's taste, for its imaginative
treatment and for a bold use of colour.
 A symbolist painter and precursor of
Surrealism, Redon was a friend of the
symbolist poet Mallarmé and much of his
work is of dreams and visions incorporated
into arrangements of flowers, giving him
the opportunity to use rich colouring.
This contrasts with his sombre
lithographs for which he is better known

73

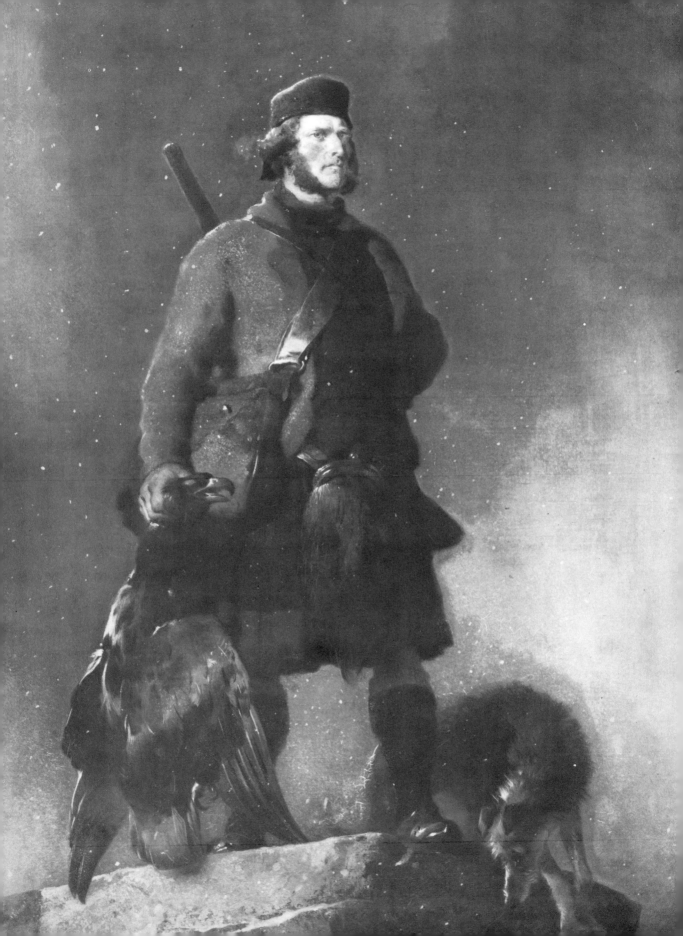

SIR EDWIN LANDSEER 1802–73

46 *Peter Coutts*

Windsor Castle. By gracious permission of
H M The Queen

Standing four square like a statue on a
plinth in a snowstorm this pastel of Peter
Coutts, the Scottish gillie, demonstrates
Landseer's extraordinary facility in the
handling of the medium. He was an
infant prodigy and is generally known for
his sentimental paintings of animals: but
his drawings and pastel heads have less of
this unfortunate quality and are full of
life and beautifully drawn. If one considers
the head of this picture in isolation one
will see how brilliantly he handles the
medium as also with the dog on the right.
There is perhaps rather too much use of
the stubbing pencil on the eagle which
results in a too smooth and slick surface,
but even so it is phenomenally skilful

JEAN-FRANCOIS MILLET 1814—75
47 *Winter with Crows*
Art Gallery, Glasgow

Millet's pictures of peasants toiling in the fields, mostly painted after 1849 when he settled in Barbizon, place him as one of the most important figures in nineteenth century France before the arrival of Impressionism. What is not generally known by the public is his draughtsmanship. His drawings are a fine record of rural life in Normandy and the Forest of Fontainbleau and are wonderfully expressive.

Millet turned to pastel in 1865 when Emile Gavet, a Parisian architect, commissioned a number from him. This landscape suggests a cold November day giving a sense of desolation and bleakness. For once there are no figures and one is conscious of the density of the earth and an almost physical reaction to it, as if one had worked on it rather than just looked at it. The harrow in the foreground adds to the impression of seemingly limitless space and the circling crows unite the earth to the sky. The stubble and clods of earth are observed and drawn with great care but do not detract from the overall tonality of the picture. I am reminded of Van Gogh's observation, in a letter to his brother Theo: 'Millet's peasants seem to be painted with the earth they till.' Millet's graphic work was admired by and influenced painters like Pissarro and Seurat, and in England the pastels of Clausen and Edward Stott

48 Detail

EUGENE BOUDIN 1824–98
49–52 *Sketches*
The Louvre, Paris
Born at Honfleur, he was a precursor of
Impressionism and a link between Corot,
whom he knew, and the younger
Impressionists like Monet, whom he
befriended. He painted seascapes and
harbour scenes and these studies in
pastel form an interesting series of notes
and comments on Normandy life, to be
incorporated into his oil paintings. The
way the figures of the women on the
plage (51) have been blocked in with the
greatest of economy of expression, using
the side of the pastel stick, is of particular
interest and should be contrasted with the
more linear and atmospheric treatment of
the yacht and mooring at the mouth of a
river. The sketch (50) of women clearing
up after a market, presumably, gives a

very good indication of the way pastel
can be used for a rapid notation of the
scene in front of one. The pastel of the
quayside at Honfleur (52) is the most
complete as a picture in its own right
and the most interesting tonally of the
group

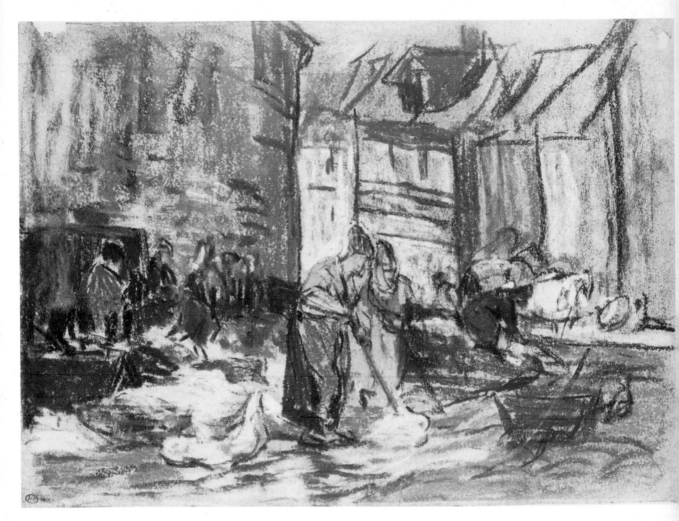

50 Women clearing up

51 Women on the plage

52 Quayside at Honfleur

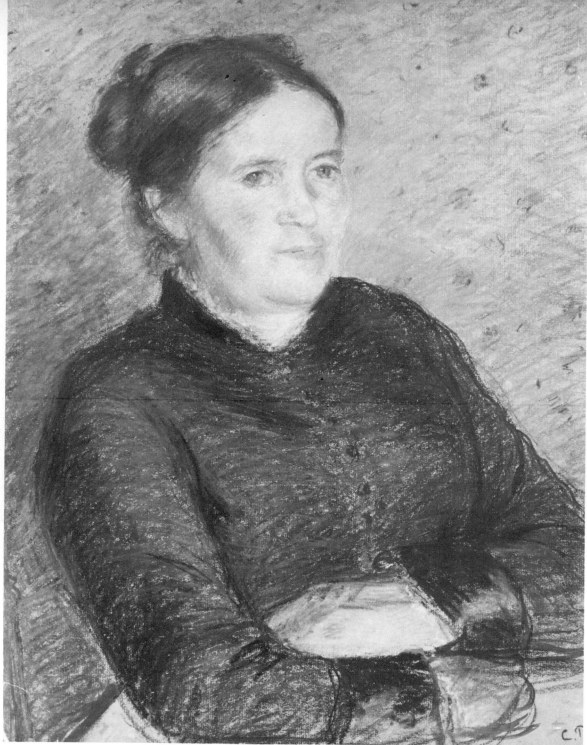

CAMILLE PISSARRO 1831–1903
53 *Portrait of Madame Pissarro*
Marlborough Fine Art (London) Limited
Pissarro exhibited in the first
Impressionist Exhibition of 1874 and he
was the most consistent of the group. His

work shows a gravity and integrity
commensurate with his characters. This
pastel of Madame Pissarro achieves
monumentality with free and open
handling of touch

82

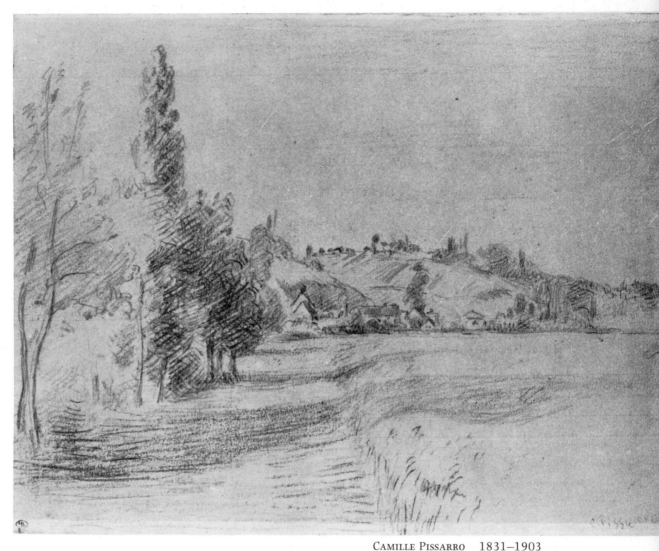

CAMILLE PISSARRO 1831–1903
54 *Paysage aux Peupliers*
The Louvre, Paris
A gentle treatment of a peaceful scene,
probably of the Normandy countryside
near Eragny, and recalling Corot, who
influenced the early work of Pissarro.
Here the pastel strokes are unfused and
laid in almost tentatively to explore the
landscape in front of him

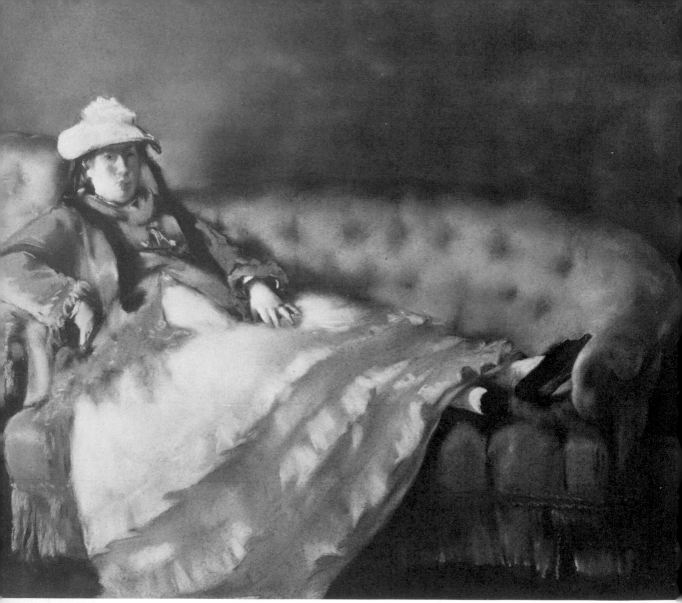

EDOUARD MANET 1832–83
55 *Madame Manet on a Sofa*
The Louvre, Paris
A much more developed pastel with fused
tones and evident rubbing. This seems
much more than an impression and has
the authority of an oil painting

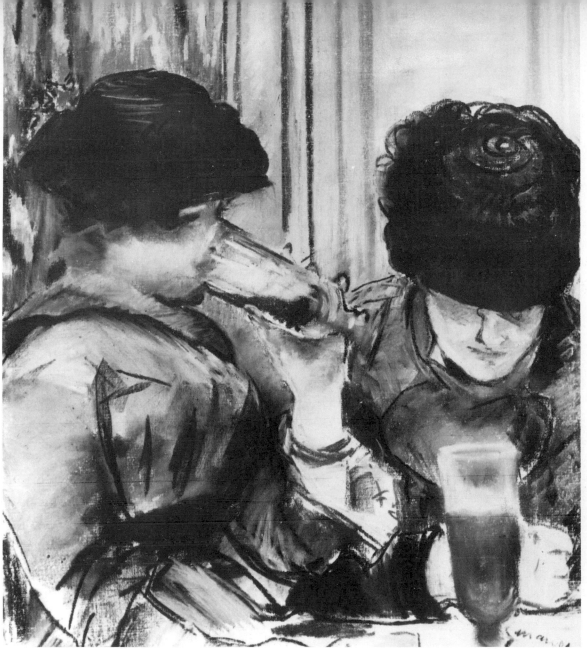

EDOUARD MANET 1832–83
56 *At the Cafe*
The Burrell Collection, Art Gallery, Glasgow

Manet turned to pastels in the eighties and it became his favourite medium until his death in 1883. He believed in getting his effects straight away without overworking and his sure and certain hand as a draughtsman allowed him to capture his impressions of his sitters almost effortlessly. In this example we see a combination of line and colour, the firm pastel lines of the background and the charcoal lines of the women's costume contrast with the black hats they are wearing. In his oils, as with his pastels, Manet understood the value of black in his colour scheme and the design of the picture and his early style, before turning to Impressionism, shows the influence of Velazquez, Goya and Hals. These Masters used black to great effect

85

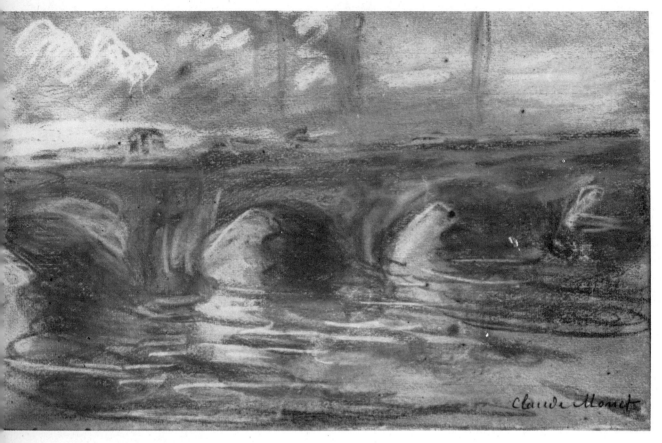

CLAUDE MONET 1840–1926
57 *Waterloo Bridge*
The Louvre, Paris
This study of Waterloo Bridge recalls the
painting and the many pictures that
Monet painted of the Thames and the
Houses of Parliament while staying at the
Savoy Hotel. It is a tremendously free use
of the medium with almost wild sweeping
strokes of the pastel crayon and just what
Monet required to give the atmosphere
and colour of the scene and the swiftly
moving water

58 Detail

JAMES McNEILL WHISTLER 1834–1903
59 *Alma Stanley*
Museum of Fine Arts Boston,
Massachusetts
The long rectangle is a shape that
Whistler was fond of using for his full
length portraits in oils, such as the
portrait of George W Vanderbilt in the
National Gallery of Art, Washington or
that of F R Leyland in the Freer Gallery,
.Washington.
This pastel adopts the same format and
clearly relates to the oil portraits in
completion and handling and contrasts
with the more widely known series of
Venetian studies, where the handling is
much freer

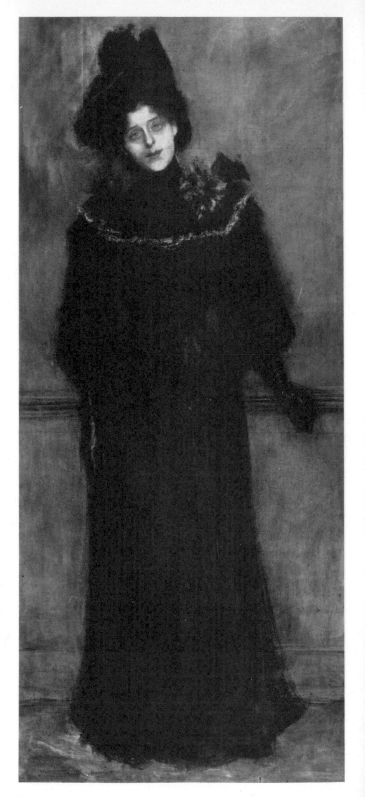

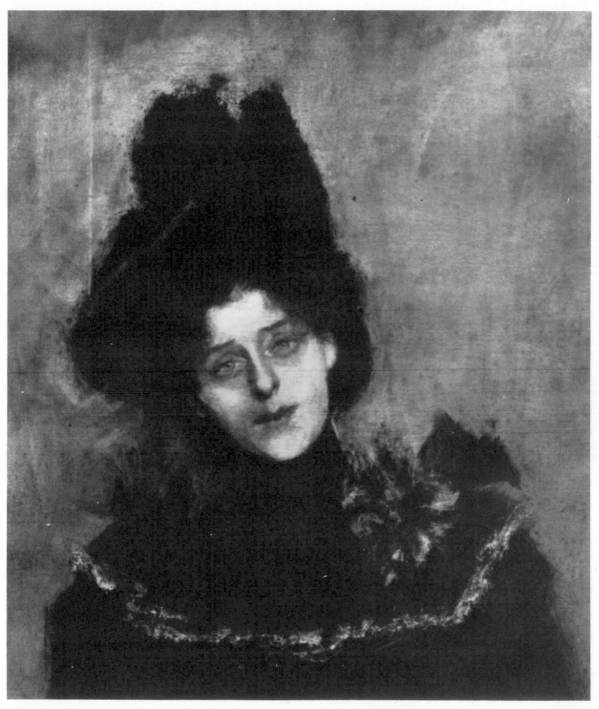

60 Detail

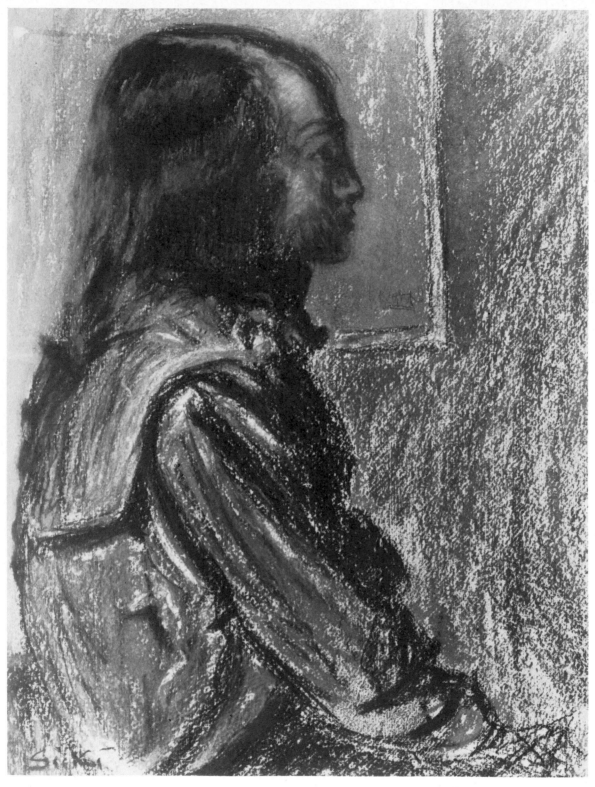

90

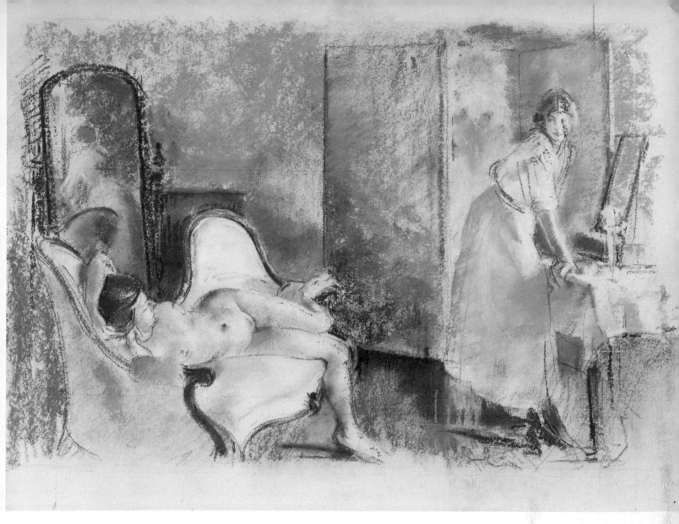

WALTER RICHARD SICKERT 1860–1942
61 *Study of a Girl*
Collection: Miss Lilian Browse
Probably painted in Venice, this pastel is
low in colour and tone like the paintings
of his Venice period. As with most of
Sickert's work, one senses the drawing
and structure all the time, and of
particular interest is the way the granule
of the paper gives a textural change in
the background. Sickert was the most
important of the English Impressionists
and associate of Whistler and Degas

HENRY TONKS 1862–1937
62 *The Toilet*
The Tate Gallery, London
Tonk's sensitive draughtsmanship and
flowing line is supported by delicate tones
of pastel, subtly blended and fused in
places and in others allowed to reveal the
grain of the paper. The composition is
interesting because the curve of the cheval
mirror is repeated by the curves of the
settee and the pose of the model lying on
it and these movements are stabilized by
the screen and the girl standing by the
mirror to the right

HENRY TONKS 1862–1937

63 *Auguste Rodin*

The Tate Gallery, London

A very fine pastel by Professor Tonks who
was the inspiration behind the tradition of
fine draughtsmanship at the Slade School.
How well he has placed the figure on the
page and how simply he has expressed the
essentials of the pose and the powerful
figure and character of the great sculptor.
The drawing has great strength, yet at the
same time the delicacy of the pastel is
preserved. This is as good as a Degas

92

64 Detail

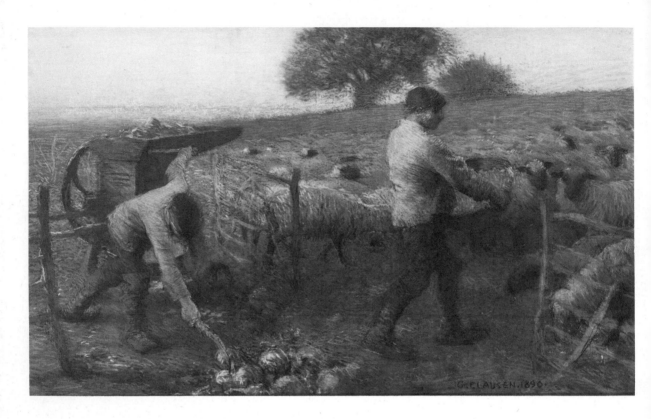

Sir George Clausen 1852–1944
65 *A Sheepfold in the Evening*
The Fine Art Society Limited, London
Clausen studied in Paris at the Academie
Julian where the source of inspiration for
many of the students can be traced to
Millet and The Barbizon School. This fine
pastel shows that influence clearly,
particularly in the treatment of the figures.
It is also interesting technically and the
pastel strokes, which build the solid form
of the composition, are clearly evident.
Clausen was an English Impressionist and
founder member of the New English Art
Club and Professor of Painting at the R A
schools from 1904–06

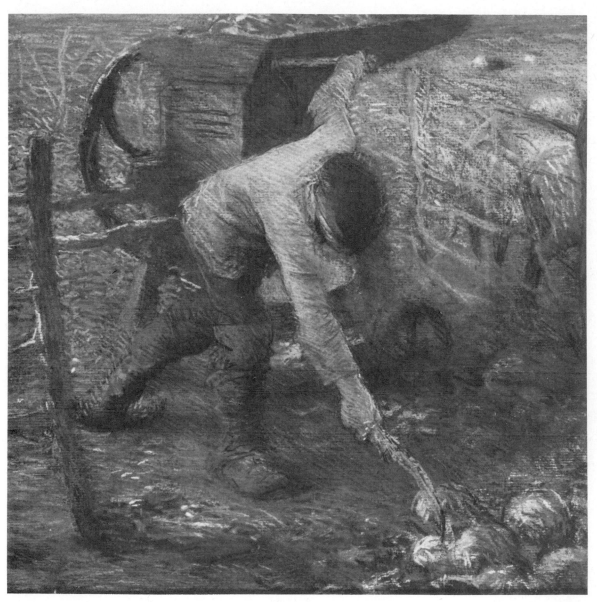

66 Detail

GUY RODDON 1919
Nude [Colour plate facing page 97]
This nude attempts to show a variety of
pastel strokes and textures. It was drawn
on fine glass paper, a surface that may be
too rough in tooth for some students but
which grips the particles of pastel powder
very well. The strokes move vertically
across the form in some places and around
the form on the arms and torso and on
the nearer leg where the pastel is also
blended with a stump. The tooth of the
support is too rough for using the hand for
this purpose. The drawing was
strengthened with charcoal

MARY CASSATT 1844—1926
Mother and Child
John J Ireland Bequest, Art Institute of
Chicago [Colour plate opposite]
Daughter of a rich banker from
Pittsburgh, Mary Cassatt worked in
France from 1868 and was closely
associated with Degas and exhibited with
the Impressionists. Her pastels, if not as
adventurous in their execution as those of
Degas, are nevertheless technically very
accomplished. Much of her work in
pastels is on the theme of Mother and
Child which she treats without
sentimentality.

This pastel is treated very freely with
broad, diagonally sweeping and open
work strokes. The colours, particularly in
the flesh, are very restrained and almost
muted. It is interesting to note that the
charcoal contour line which describes the
child's back is preserved to retain the
drawing, but is softened by allowing the
pastel strokes to move gently across it.

Many of Mary Cassett's pastels are
counterproofs. That is the original pastel
is covered with a sheet of dampened
paper and run through a lithographic
press. The chalk design of the original is
transferred to the sheet and both versions
worked on by the artist. Vollard, the
picture dealer, had counterproofs made by
Cassatt, Renoir and Degas

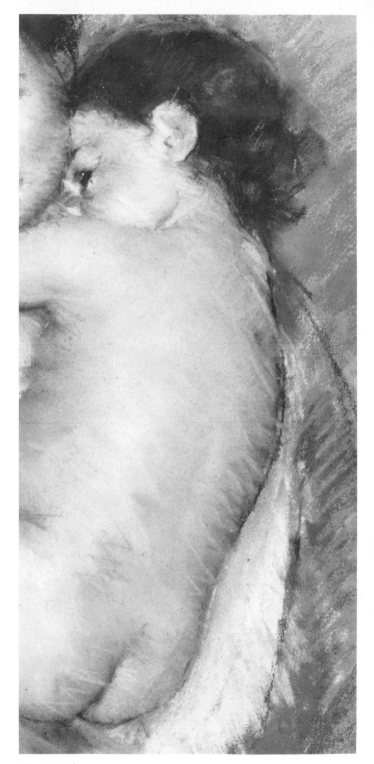

67 Detail

96

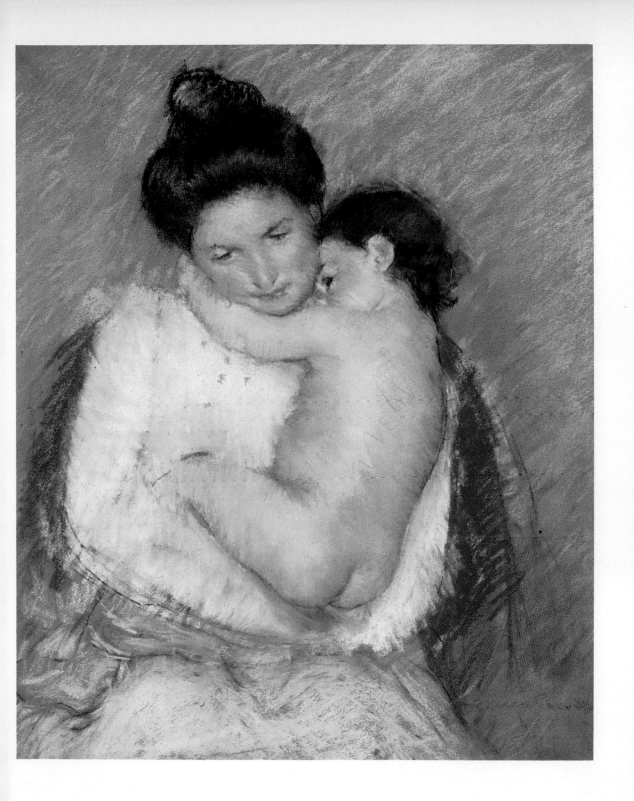

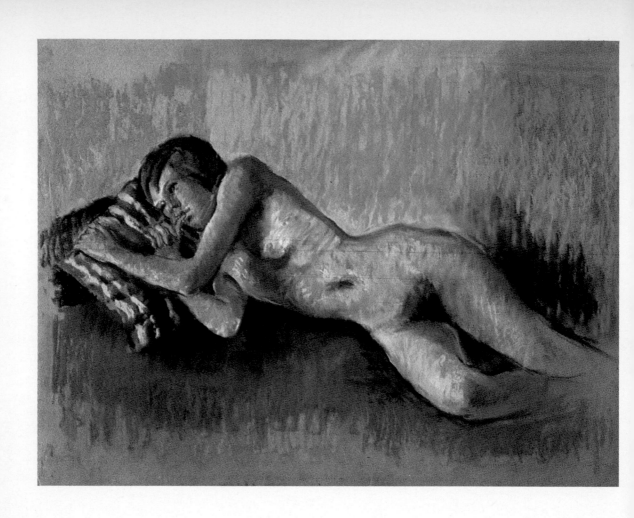

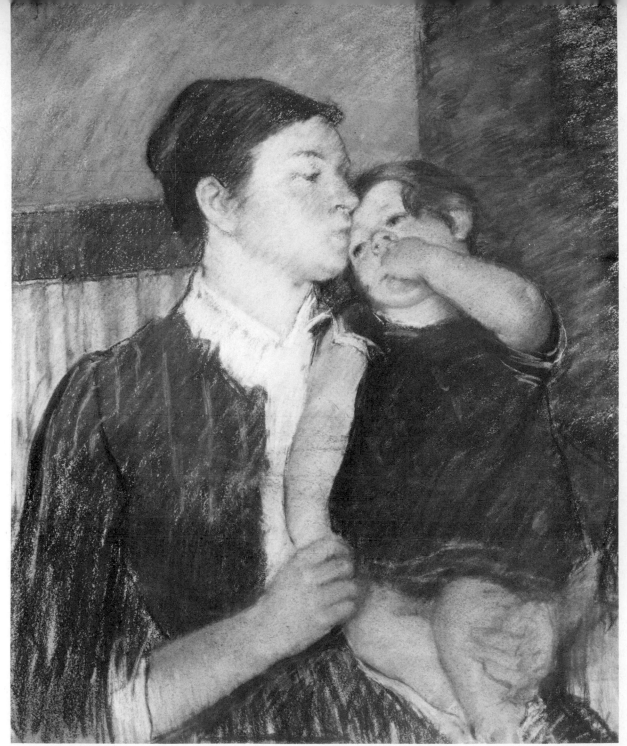

MARY CASSATT 1884–1926
68 *Mother and Child* 1880
Potter Palmer Collection,
The Art Institute of Chicago
Another pastel on the theme of maternity.
Although as free in treatment as the

colour reproduction facing page 96, this
is a more closely knit design and a greater
concentrated image. The pastel strokes
move diagonally across the well modelled
form

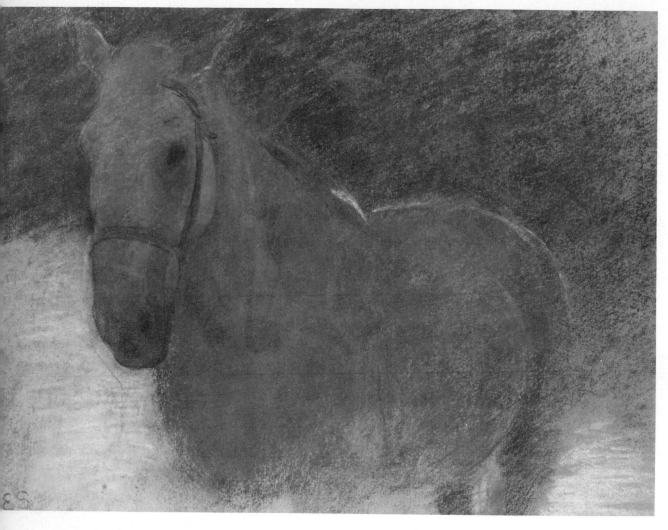

EDWARD STOTT 1855–1918
69 *The White Horse*
The Fine Art Society Limited, London
Edward Stott studied in Paris in 1882–3
and his paintings of English pastoral
scenes, mostly located around Amberley
in Sussex, show the influence of Millet
and Bastien-Lepage. He was a founder
member of the New English Art Club.

This pastel study is a good example of
what may have been a preparatory sketch
for an oil painting

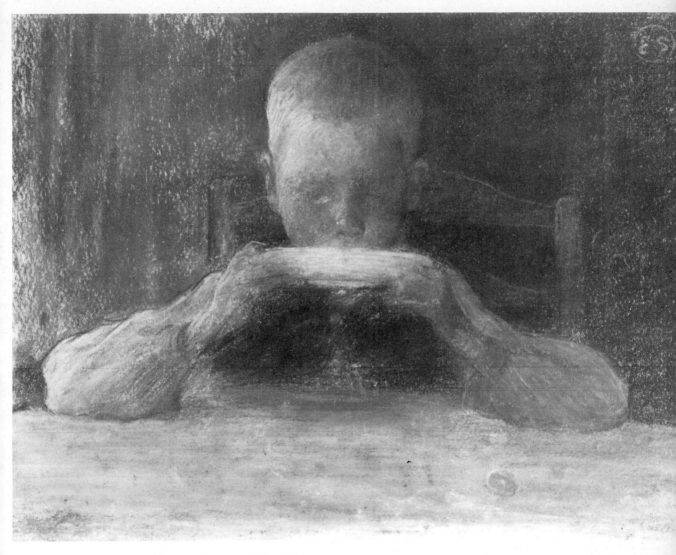

EDWARD STOTT 1855–1918
70 *Boy at Breakfast*
The Fine Art Society Limited, London
A moving study for 'Sunday Morning'.
This beautiful pastel is a complete
statement in itself. Stott has been
described as the 'English Millet'

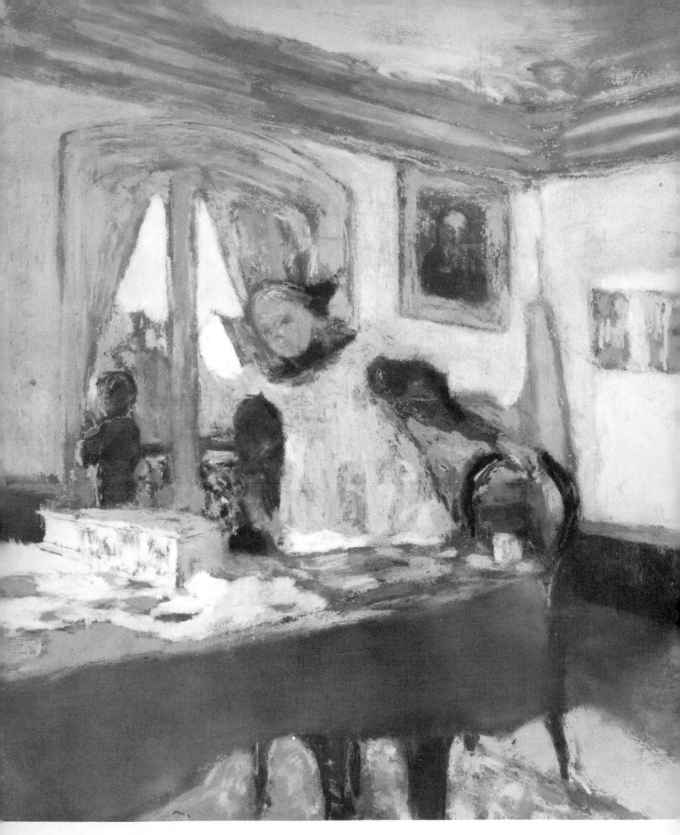

EDOUARD VUILLARD 1868—1940
71 *The Laden Table*
The Tate Gallery, London
Copyright SPADEM Paris 1978
An intimist painter and friend and
associate of Bonnard. A number of his
pastels, as well as his oils, are of interiors
and painted in some cases on cardboard.
This pastel is probably painted on a
similar ground and is described in the
Tate Gallery catalogue as a gouache
pastel, since the pastel in most parts of
the picture has turned into a paste. The
composition is interesting since Vuillard
has concentrated on the pattern of the
shapes. Although low in key, he has
forced the lights, as for instance the
building through the window behind the
girl, as well as the light showing through
the open door to the right of the picture.
This has the effect of bringing the distance
forward to the picture plane, although
space is still implied, and allows the play
of abstract shapes to reveal their full
meaning

GEORGE HENRY
72 *Girl Reading*
The Fine Art Society Limited, London
Collection of Andrew McIntosh Patrick
Charcoal drawing on grey paper with
pastel on neck and head

PAUL NASH 1889–1946

73 *The Field at Passchendaele*

The Imperial War Museum, London

Paul Nash served in both World Wars as
an Official War Artist. Like Kennington
and other British artists, some of the best
of twentieth century painting was
executed under the stress of war. Nash,
who later exhibited with the Surrealists
has captured the terrible beauty of the
battlefield which he knew at first hand. It
is a visual equivalent of the poetry of
Wilfred Owen. The picture appears to be
carried out with chalks and hard pastel on
dark toned paper and the contrasts of dark
and light emphasize the starkness of the
subject

103

ROBERT BUHLER, RA 1916
74 *The Lady Prudence Branch*
Artist's Collection
A distinguished pastel by an acknowledged
contemporary master of the medium.
This pastel is noteworthy for it shows
clearly the logical and systematic stages
of a development from the preliminary
key drawing through the various layers
to the final unfused strokes. The handling
of the pastel is full of variety and interest
giving an impression of spontaneity. Yet
really this effect is the result of careful

planning. The structure of the head is
firm and fully grasped; the disposition
of the light and shade, the modelling by
the planes and the subdivision of tones
are all contained within an imposing
silhouette, fully placed on the page.
The artist used a palette of white, ochre,
warm and cold reds and green and mauve
lilac. The half-tones were achieved by
superimposed layers of unfused
complementaries giving an optical grey,
very much in the manner of Degas.

104

Stages in the making of pastels

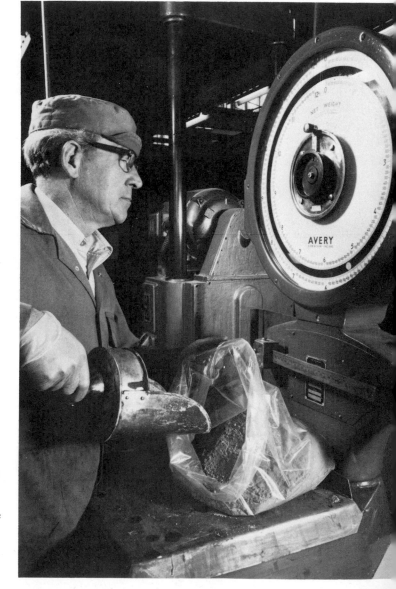

Stages in the making of pastels
By courtesy of Rowney Ltd
These illustrations from the Rowney factory show the commercial manufacture of pastels, which although using sophisticated machinery relies on the individual skill of each operator to produce the right quality of pastel stick.

75 Weighing the raw material, which is, of course, the powder colour

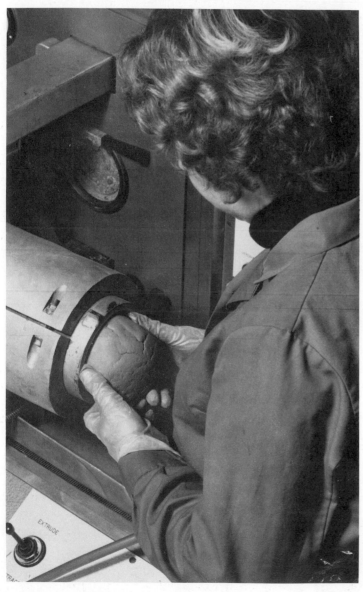

76 The solid mass of powder colour mixed with gum tragacanth and a filler is fed through a cylindrical tube which shapes it to the appropriate size

107

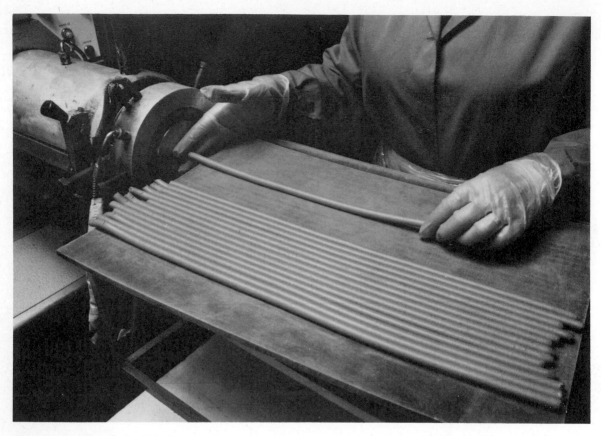

77 The lengths of pastel stick emerge
from the cylinder

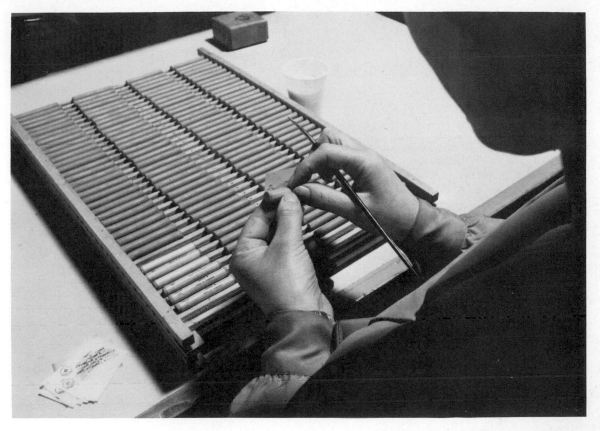

78 The paper covering is individually rolled
Pastels may also be made by hand by the artist in the studio. The process is fully described by Ralph Mayer in the *Artists Handbook*, Faber

Glossary

CASEIN A useful priming for pasteboard and paper. An extract of milk. It is a damp proof, but brittle size. A proprietary brand of casein size, such as Casco, will dissolve in cold water.

CHALK Calcium carbonate. Precipitated chalk is the basis for pastels. The terms crayon, chalk or pastel were sometimes confused. The word crayon derives from the French *craie* (chalk).

CHARCOAL Made from twigs of willow or vine. Compressed charcoal is harder and less friable and is also the basis of charcoal pencils.

CONTE CRAYON These crayons are semi-hard, finely textured and have an oily material in the binder. They do not dust off as does charcoal. Some crayons have wax as a binder but are no use when employed with soft pastels.

CROSS HATCHING A form of shading by using diagonal lines crossing each other.

DISTEMPER Painting with pigments ground with size. Degas mixed his colour with hot size – *détrempe a la colle* – which he sometimes used in conjunction with his pastel drawing.

FIXATIVES A solution for fixing, preserving and preventing the smudging of pastels. Most commercial fixatives are shellac based and sprayed with an atomizer or mouth spray. But they can be made from a solution of casein and La Tour used Isinglass, a fish glue.

FOXING Stains on paper or card caused by damp.

GOUACHE An opaque water-colour paint.

GUM TRAGACANTH The binder for pastels, is a resin from a shrub found in Asia Minor. It can be bought already made up or in its natural state in ribbon like pieces when it is soaked overnight in water.

IMPASTO Thickly applied paint or pastel.

LAY-IN The preliminary drawing for a pastel. Sometimes a key-drawing is used. Not to be confused with LAY-OUT.

LAY-OUT LAY-OUT is generally a rough sketch which commercial artists draw on a lay-out pad.

MODULATIONS Transitions from one tonal passage to another.

A weak solution of glue used for priming supports or as a medium in distemper. The four principle categories are: (1) Leather waste, in sheet form. Parchment and rabbit skin glue. (2) Bone and cartilage, in granules. Commercial glue size and decorators size. (3) Milk in powdered form. Casein. (4) Fish in liquid form. Isinglass. | SIZE

Soft paper rolled in the form of a pencil, sometimes pointed at both ends, and used for fusing and blending the pastel for delicate transitions of tone. | STUMP or TORCHON

Not to be confused with any form of easel, this term is used to describe the surface on which the pastel is drawn, ie, paper, card, felt, muslin, canvas. | SUPPORT

Gradations of tone from light to dark. The tones of any solid object can best be judged through half-closed eyes when the colour does not obtrude to confuse the issue. Halftones, mentioned in the text, are very important middle tones and difficult to perceive. | TONE

Generally applied to the texture of a canvas, can also be used to describe the grain of the paper. Particularly in the case of sand paper or glass paper. | TOOTH

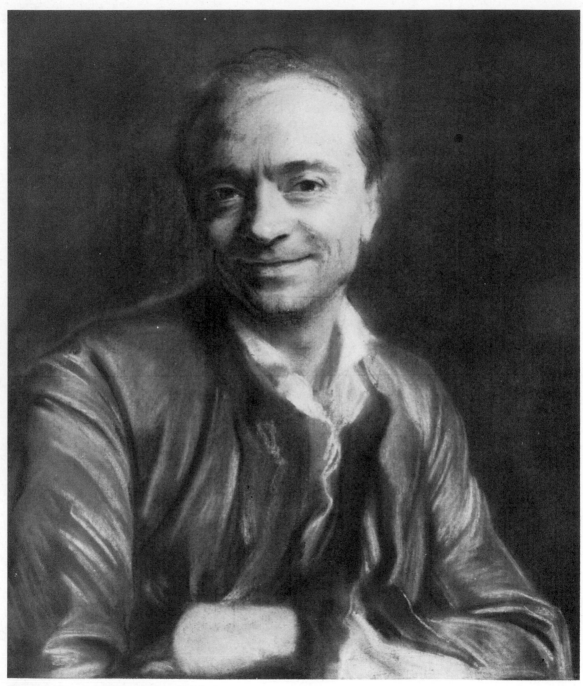

MAURICE QUENTIN DE LA TOUR 1704–88
79 *Selt Portrait*
The Louvre, Paris

Mcfall, Haldane, *The French Pastellists of the Eighteenth Century*, Macmillan
Bury, Adrian, *Quentin de la Tour*, Charles Skilton
Adair, V. and L., *Eighteenth Century Pastel Portraits*, Gifford
Rewald, John, *Edouard Manet Pastels*, Bruno Cassirer
Werner, Alfred, *Degas Pastels*, Cresset Press
Rouart, Henri, *Degas A la Recherche de sa technique*, McGraw Hill
Cooper, Douglas, *Degas Pastels*, Simpkin Marshall
Rouart, Denis, *The unknown Degas and Renoir*, McGraw Hill
Pollock, Griselda, *Millet*, Oresko Books
Selz, Jean, *Odilon Redon*, Uffici Press, Lugano
Moreau-Vauthier, *Technique of Painting*, Putnam
Mayer, Ralph, *Artist's Handbook*, Faber
Wehlte, Kurt, *Materials and Techniques of Painting*, Van Nostrand Rheinhold
Doerner, Max, *Materials of the Artist*, Hart, Davis
Russell, John, *Elements of Painting with Crayons*, 1777
Whitley, William, *Artists and their Friends in England*,
Williamson, G.C., *Daniel Gardner and John Russell*, 1894
Goncourt, Edmond and Jules, *French Eighteenth century Painters*,
Constable, W.G., *The Painter's Workshop*, O.U.P.
Gordon, Louise, *Drawing the Human Head*, Batsford
Gordon, Louise, *Anatomy and Figure Drawing*, Batsford

Bibliography

Suppliers

Great Britain

L Cornelissen and Sons
22 Great Queen Street
London WC2

Robersons and Company Limited
71 Parkway
London NW1

George Rowney and Company Limited
10 Percy Street
London W1

Winsor and Newton Limited
51 Rathbone Place
London W1

United States

Arthur Brown and Bro Inc
2 West 46 Street
New York, NY 10036

Grumbacher
460 West 34 Street
New York

New Masters Art Division
169 Waverley Street
Cambridge, Massachusetts

Winsor and Newton Inc
555 Winsor Drive
Secaucus, New Jersey 07094

*See Yellow Pages
for Artists' Colourmen*

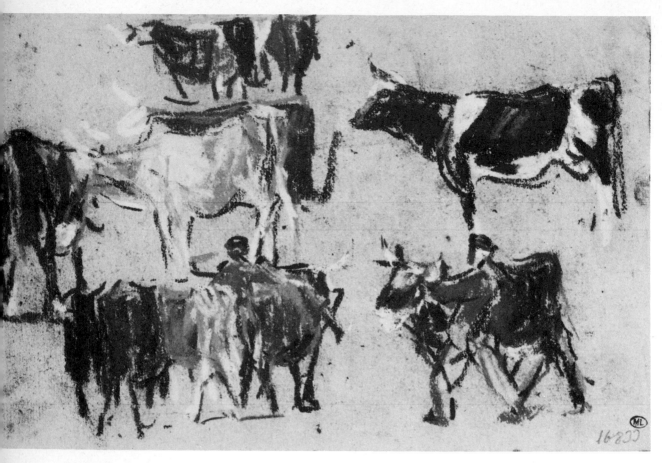

EUGENE BOUDIN 1824–88
80 *Sketches*
The Louvre, Paris

Index

Anquetin, Louis 32; works, *Girl Reading a Newspaper* 33
Art Institute of Chicago 7
Ashmolean Museum, Oxford 7

Barbizon School 94
Bastien-Lepage, Jules 98
Boudin, Eugene 78; sketches 78, 79, 80
Bonnard, Pierre 101
Boston Museum of Fine Arts 7
Brangwyn, Sir Frank 60
Brighton Art Gallery 58
British Museum 10
Buhler, Robert 60; works, *The Lady Prudence Branch*, 104
Bury, Adrian 60

Canvas, pastel works on 28
Carriera, Rosalba, 57–8, works, *Jeune Fille Tenant un Singe* 59
Cassatt, Mary, 7; works, *Mother and Child* 96, 97; colour plate facing page 96
Cézanne, Paul 67
Charcoal, use of 36
Chardin, Jean Baptiste Simeon 7, 57–8, 60, 67; works, *Self-portrait* 66
Clausen, Sir George 76; works, *A Sheepfold in the Evening* 94–5
Colours, blending 27
Constable, Professor 39; works, *The Painters' Workshop* 39q
Cooper, Douglas, 42; description of Degas' method of modelling by colour and line 42
Corot, Jean Baptiste Camille 78, 83
Cotes, Francis 57–8

Degas, Edgar 7, 9, 13, 14, 32, 40, 42, 44, 49, 58, 68, 73, 90, 92, 104; use of distemper paint by 46; works, *Mademoiselle Malo* 37; *Miss Lola at the Cirque Fernando* 47; *Woman at her Toilet* 48
Delacroix, Eugene 26; works, *Study for the Death of Sardanapalus* 68; *Study for Femmes D'Alger* 69; *Etude de Ciel, Crepuscule* 70
Design, lay-in of 27, 32, 36
Dijon Museum 39
Distemper: paint, use of with pastel, 46; painting, 49; painting with 26
Doerner, Max 49 fixative recommended by 49
Drawing 14
Dring, William 60

Egg, use of in colouring paper 25–6

Fitzwilliam Museum, Cambridge 7
Fixatives: arguments for and against use of 49; when spraying 50

Flock, pastel marks on 28
'Foxing' 50
Fragonard, Jean Honoré 12
Freer Gallery, Washington 88

Gardner, Daniel 58
Gavet, Emile 76
Glasgow Art Gallery 44
Glass paper, pastel marks on 28
Gouache, use of with pastel 46
Goya y Lucientes 85
Grumbacher, Messrs 20

Hals, Franz 85
Henderson, Keith 25
Henry, George; works, *Girl Reading* 102

Impressionist Exhibition 82
Impressionism(ists) 58, 70, 73, 78, 85, 90, 94

Johnson, Dr 58

Kennington, Eric 22, 36, 60, 103; works, *The Cup Bearer* 25; *Lord Halifax* 38

Landseer, Sir Edwin 12; works, *Studies of Tigers and a Leopard* 10; *Studies of a Lion's Head* 11; *Study of a Cow* 71; *Peter Coutts* 75
Lawrence, TE, 36, 60; works, *Seven Pillars of Wisdom* 36q, 60q
Le Franc, Messrs 21
Loriot, 49

Mallarmé, Stéphane 73
Manet, Edouard 7, 12, 28, 42, 58; works, *George Moore* 44; *Madame Manet on a Sofa* 84; *At the Cafe* 85
Mayer, Ralph 49, 51; method of mounting pastel 51
Merriott, Jack 51; method of mounting pastel 51
Metropolitan Museum of Art, New York 7, 44
Millet, Jean-Francois 94, 98; works, *Winter with Crows* 76
Modelling: by tone 39; by colour 42, 44
Monet, Claude 78; works, *Waterloo Bridge* 86
Monotype, use of with pastel 46
Moore, Henry 46
Muslin as support for pastel 26, 28

Nash, Paul 36, 39, 60; works, *The Field at Passchendaele*, 103
National Gallery, London 7, 64
National Gallery of Art, Washington 88
New English Art Club 98
Numbering systems for references of tints 15, 20

115

Over modelling 44
Owen, Wilfred 36, 103

Palette: working 15, 20; for
 portraiture, suggested 21
Paper: surfaces and supports,
 differing 22, 26; preparing 25;
 colouring, 25; texture of
 supports 26
Papers: Ingres type, 22; Fabriano
 Ingres 22; Ingres Tumba 22;
 Ingres Canson 22, 34;
 preparation with water colour
 or gouache wash by some
 artists, 25; pastel marks on 28
Pastel(s): charm of 9;
 characteristics of 9; recipe for
 success of p. picture 9;
 mistake in 9; composition of 9,
 12; advantages and
 disadvantages of 12–13;
 marks on different surfaces 28;
 systematic planning of 32;
 lay-in of 36; first lay-in 39, 42;
 developing after mixing with
 other media 46; fragility of 51;
 method of mounting and
 framing 51–5; storing 56;
 history of 57–8; revival of lost
 popularity 58; stages in
 making of 106–9
Pastel pencils 27
Pastel Society, 58; members of 60
Pastel stick 26–7, 106
Pastello as origin of word pastel 49
Perronneau, Jean Baptiste 7, 32,
 39; works, *Girl with a Kitten*
 62–4 *Pierre Bouguer* 65
Pfeiffer, Franz-Joseph, works,
 Marie-Caroline Deckers 67
Picture, best way of starting 32
Pissarro, Camille 76, 83; works,
 Portrait of Madame Pissarro 82

Raffaelli 58; invents soft pastel 58
Redon, Odilon, works, *Ophelia* 72,
 73; colour plate facing page 72
Renoir, Pierre Auguste 42, 73
Reynolds, Sir Joshua 58
Roddon, Guy 32; works, *Harriet
 Gilbert* 23, 29; *Olive Parslow*
 30–1; *The Arcades, Dieppe*
 34–5; *Nude* 73 (mentioned –
 The Cafe in the Arcades, Dieppe)
 32; colour plate facing page 73

Romney, George 58
Rothenstein, Sir William 42
Rouart, Denis 46; works, *Degas:
 a la Recherche de sa Technique* 46q
Rowney & Co, Messrs 15, 20–1,
 106; boxing up pastels 20;
 portrait box of tints
 produced by 21
Rubens, Peter Paul 25
Russell, John 58; works, *The
 Elements of Pastel Painting* 58q

Sargant, John Singer 60
Seurat, Georges Pierre 76
Sickert, Walter Richard; works,
 Study of a Girl 90
Slade School 92
Stott, Edward 76; works, *The
 White Horse* 98 *Boy at
 Breakfast* 99
Surrealism 73

Talens, Messrs 15, 18, 20
Tate Gallery, London 7, 32, 101
Tint charts 15, 18–20
Tonal modulations 42
Tone: definition of 39;
 relationship of to colour 39, 42
Tonks, Henry: works, *George
 Moore* 43; *The Toilet* 90;
 Auguste Rodin 92–3
Tour, Maurice Quentin de la 7,
 12, 25–6, 32, 39, 49, 57, 58;
 66; works, *Self-Portraits* 40–1;
 colour plate facing page 73,
 Madame De Pompadour 61;
 letter to Marquis de Marigny
 32q
Tuke, Henry Scott 60

Van Gogh, Vincent Willem 76
Velasquez, Diego de Silva y 85
Vollard, picture dealer 44, 73
Vuillard, Edouard; works, *The
 Laden Table* 101

Walpole, Horace 57–8
Water colour, use of with pastel 46
Watteau, Jean Antoine 12
Watts, George Frederick 60
Weber, F, Messrs 20
Whistler, James McNeill 25, 60,
 90; works, *Alma Stanley* 88

WATERLOO HIGH SCHOOL LIBRARY
1464 INDUSTRY RD.
ATWATER, OHIO 44201

Pastel painting tech. 17517
Rodden, Guy 741.2 ROD

741.2 Roddon, Guy
ROD
 Pastel painting
 techniques

DATE			
1/6/03			

© THE BAKER & TAYLOR CO.